THE WATERCOLOURS AND DRAWINGS OF
THOMAS BEWICK
AND HIS WORKSHOP APPRENTICES

VOLUME ONE

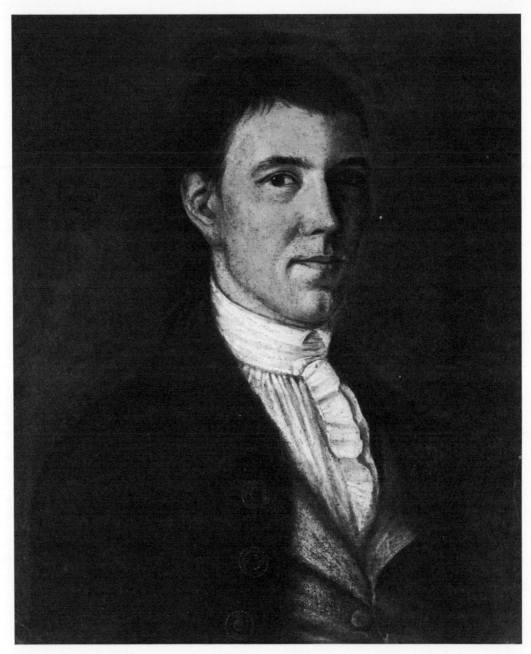

Bewick as a young man, by George Gray, *c.*1780. 22½ × 18in. (Laing Gallery)

THE WATERCOLOURS

AND DRAWINGS

OF

THOMAS BEWICK

AND HIS WORKSHOP

APPRENTICES

INTRODUCED AND WITH

EDITORIAL NOTES BY

IAIN BAIN

VOLUME

ONE

GORDON FRASER

LONDON

First published 1981 by
The Gordon Fraser Gallery Ltd, London and Bedford
Copyright © Iain Bain 1981

BRITISH LIBRARY CATALOGUING IN PUBLICATION DATA

Bain, Iain
 The watercolours and drawings of Thomas Bewick
 and his workshop apprentices.
 Vol. 1
 1. Bewick, Thomas
 I. Title II. Gordon Fraser Gallery
 769.92'4 NE1147.6.B47

ISBN 0–86092–057–7

Set in Monophoto Ehrhardt and printed by
Westerham Press, Westerham, Kent
on Bewick Cartridge supplied by Frank Grunfeld Ltd
Bound by G & J Kitcat Ltd, London
Designed by Peter Guy

CONTENTS

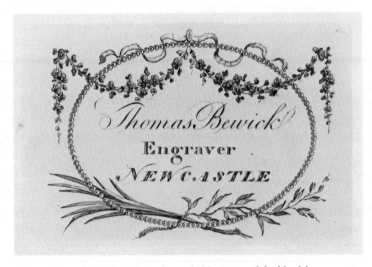

1: Bewick's trade card – probably engraved for his visit
to Edinburgh in 1823.

PREFACE

The mastery of his wood engraving brought Thomas Bewick an early and a lasting fame. Ever since his death in 1828 he has been the subject of a continuing stream of books and articles, and some account of him now appears in virtually every work relating to the history of the relief print. But despite this, the background of his working life as a copperplate printer and trade engraver on metals has never been thoroughly understood. Likewise, the world is still very largely ignorant of Bewick as a draughtsman and colourist, and of the fact that like many another artist-craftsman he always had two or three apprentices under instruction to whom, as part of their training, he delegated much of his work. Although Bewick's drawings were the subject of admiration for the few people lucky enough to see them, it seems that some of the earlier ones were destroyed, and there was no substantial exhibition of them in his lifetime. Fortunately, as his children grew up, they began to treasure the relics of their father's draughtsmanship and only the most pressing visitors were able to secure the relatively few subjects now outside the three principal collections in Newcastle and London. In 1880, not long before their deaths, his daughters Jane and Isabella allowed a large number to be given their first formal showing, at the Fine Art Society in London. The exhibition was organised by David Croal Thomson who was at the time writing a life of Bewick. The catalogue notes were provided by F.G. Stephens and it is curious to find that nowhere is there discussion or even an awareness of the contribution made by Bewick's apprentices – either to the drawings, or to the engravings that accompanied them. The same can be said of Thomson's book *The Watercolour Drawings of Thomas Bewick* written at the end of his life and published shortly after his death in 1930. It was a labour of love, printed in a small edition, with forty subjects reproduced in colour. Like his agreeable and perceptive biography of Bewick published nearly fifty years earlier, it was written without the aid of an extensive archive of papers in the possession of Bewick's daughters and their descendants. Jane and Isabella had seen him as a 'foreigner', not being from Newcastle, and though he was granted a very guarded interview, Thomson sadly secured no real assistance. Despite a fading memory, Isabella, who saw him, might well have provided uniquely valuable evidence now lost to us. This disappointment apart, for someone so active as an art critic and gallery manager, Thomson was surprisingly unaware of distinct differences of style to be seen in several groups of drawings catalogued under Bewick's name.

Besides a handful of independent studies on a larger scale, the 1,400 or so subjects now recorded – from slight pencil preliminaries to highly finished watercolours – are for the most part directly related to intended or published

engravings on wood or metal. Although Bewick's reputation as an artist must stand principally on the unique qualities to be found in his engravings, his drawings deserve wider notice. In the greater number and range of subjects reproduced (now for the first time shown beside the engravings derived from them), in the observation of the stylistic variations and the evident apprentice contribution, and in the use of hitherto neglected manuscript sources, this book will, I hope, encourage a better informed delight in the workings of Bewick's genius.

ACKNOWLEDGMENTS

In the making of this book I have had nothing but kindness and help from the many people whose busy days have been interrupted by my enquiries. On many visits to the Natural History Society of Northumbria, Newcastle upon Tyne, I have had very great assistance from Mrs Grace Hickling, Honorary Secretary. Mr John Gere, Keeper, and Mr Reginald Williams, of the Department of Prints and Drawings, British Museum, and Mr Arthur Wallace, City Librarian, Miss J.W. Thompson and Mr Douglas Bond of the Central Library, Newcastle upon Tyne, have provided ready access to their collections on numerous occasions. In America, Mr James Wells of the Newberry Library, Chicago, and Miss Eleanor Garvey of the Department of Printing and Graphic Arts, Houghton Library, Harvard University, have likewise been most kind.

The extraordinary assembly of Bewick papers until recently in the care of the Laing Art Gallery and Museum, Newcastle upon Tyne, has been a vital source of reference, and my access to it has been encouraged and greatly assisted by the Gallery's former Director, B. Collingwood Stevenson, and by Mr Andrew Greg and Miss Gill Hedley.

More than ten years ago, Sir Geoffrey Keynes set in train my serious interest in Bewick's life and work by lending me a number of valuable manuscripts in his collection. His friendship and enthusiasm have since been a constant source of inspiration. Later, in the autumn of 1975, Professor John Widdess passed over to my care several hundred items of Bewick's correspondence and other papers, which have since provided me with essential background material. My visit to his home in County Kerry gave me three days of unforgettable interest and excitement.

For permission to reproduce works in their collections I am most grateful to the Natural History Society of Northumbria, the Laing Art Gallery and Museum, the Central Library (Pease Collection), Newcastle upon Tyne, the Trustees of the British Museum, the John M. Wing Foundation, Newberry Library, Chicago, and the Trustees of the National Portrait Gallery, London.

To Greer and Sue Allen, Gavin Bridson, David and Elsey Burleigh, David Chambers, J.S. Dearden of the Ruskin Galleries, Bembridge, Isle of Wight, Judy Egerton, Dr Edward Ford, Bewick Hack, Mrs John Hack, Marshall Hall, Dr Colin Harrison, W.H. Hedworth, Professor C. Heppner, William Hesterberg, Robert Hunter Middleton, the Hornby Art Library, S.T. Lawrence, Crimilda Pontes, Edmund Poole, Simon Rendall, S. Dillon Ripley and David Steedman, I owe thanks for assistance in many forms.

I shall ever regret that Reynolds Stone did not live to see the completion of this book. In his own work as an artist

[9]

and engraver he had done so much to keep Bewick's skills alive. The project was dear to his heart and this did much to encourage its progress.

The quality of the reproductions owes a great deal to John Webb's photography, and to the unceasing care and enthusiasm of John Parfitt of the Westerham Press. Although by tradition the publisher's part is taken for granted, Mr Gordon Fraser's extraordinary generosity towards the production of the book cannot pass without remark. Peter Guy and Simon Kingston have been the most sympathetic of kindred spirits in matters typographical and editorial.

EDITORIAL NOTE

All the drawings have been reproduced in their original size and are shown together with their related engravings wherever these exist. In a very few cases the full extent of the paper on which they have been drawn has been very slightly cropped. The figures of the *Quadrupeds, Birds* and *Fables* have been given the titles of their first appearance, with a few later variations noted; the titles of the tail-piece vignettes are shown within quotation marks if taken from original sources – otherwise they have been freshly coined or adapted from other sources. The date of engraving has been taken wherever possible from the workshop records, and otherwise from the date of first publication when known. The attributions are based on my own study of the material; those of W.A. Chatto are also noted whether or not they agree (see note below and Introduction, Vol.1, p.69). The term 'transfer drawing' has been used to denote that there is visible evidence of the drawing's use as a means of securing the principal outlines of the subject on the engraving surface.

ABBREVIATIONS AND REFERENCES

NATURAL HISTORY SOCIETY OF NORTHUMBRIA and BRITISH MUSEUM: these have the two largest collections of drawings. Notes on them and on other collections are given on pp.224–5.

WYCLIFFE MUSEUM: the Museum and Natural History collection of Marmaduke Tunstall, of Wycliffe, North Yorkshire, where Bewick stayed for two months in 1791 as the guest of Tunstall's heir in order to start work on the drawings for his *British Birds* (see Vol. 1, p.34). George ALLAN, the antiquary, of The Grange, Darlington, bought and enlarged the collection and was a continuing source of information for Bewick.

LAING GALLERY: the main collection of original workshop records was until recently in the care of the Laing Art Gallery and Museum, Newcastle upon Tyne. It has since been moved to the Archives Department of the Tyne and Wear County Council, Blandford House, Newcastle upon Tyne. Records quoted are given the volume number as catalogued at the gallery.

PEASE COLLECTION: The Bewick collection bequeathed to the City of Newcastle upon Tyne by J.W. Pease, and now housed in the Central Library.

FORD MSS: Papers in the collection of Dr Edward Ford whose great-grandfather knew Bewick's daughters. He corresponded with them, and bought from them a number of their father's drawings, blocks and other materials.

V & A: three 'Weekly Engraving Books' from the workshop are now in the library of the Victoria & Albert Museum. Their identifying dates are given when used as a source.

JANE BEWICK'S MS: in 1869 Jane Bewick began to compile a series of notes on the narrative content of her father's tail-piece vignettes. These are now in the Editor's collection.

JANE BEWICK V&A: an annotated copy of the 1821 edition of the *Birds* contains supplementary notes on the tail-pieces also compiled by Jane Bewick.

CHATTO: W.A. Chatto and John Jackson's *Treatise on Wood Engraving*, 1839, contains the printed record of Chatto's enquiry into Bewick's drawings and engravings and their attributions. This was derived from the MS now in the LONDON LIBRARY: besides being more extensive, in a number of cases it contradicts the published record. Both sources are quoted. See Vol. 1, pp.69ff.

ATKINSON: G.C. Atkinson, 'Sketch of the Life and Works of the late Thomas Bewick' in the *Transactions of the Natural History Society of Northumberland, Durham and Newcastle upon Tyne*, i. 1831.

DOBSON: Austin Dobson, *Thomas Bewick and his Pupils*, 1884.

ROBINSON: Robert Robinson, *Thomas Bewick, His Life and Times*, 1887.

THOMSON: David Croal Thomson, *The Life and Works of Thomas Bewick*, 1882.

DOVASTON: Gordon Williams (ed.), *Bewick to Dovaston, Letters 1824–1828*, 1968.

HUGO: Thomas Hugo's *The Bewick Collector*, 1866, with its 1869 supplement, is valuable for the amount of material surveyed, but is a slipshod work, containing much of doubtful attribution.

MEMOIR: Iain Bain's edition of Thomas Bewick's *Memoir*, 1975, is the first to contain the authentic text. All references and quotations relate to this edition.

Unless otherwise noted, illustrations in the Introduction are from the Editor's collection. Dimensions are given for all prints and drawings where these are not shown in their original size.

INTRODUCTION

Although the further materials for the study of Bewick's life are now found to be extensive, what we can discover of his childhood remains limited to his own account given in the posthumously published autobiographical *Memoir*. This was written during the last six years of his life, between 1822 and 1828, and as might be expected, the story of his youth provides some of the most attractive passages. Quite free of the faults often found in the fond recollections of the elderly, Bewick's record of his first awareness of a talent for drawing has an attractive simplicity and freshness:

After being sometime kept at reading, writing & figures, how long I know not, but I know that as soon as my question was done upon my Slate, I spent as much time as I could find, in filling, with my pencil, all the other spaces of it, with representation of such objects as had struck my fancy, and these were rubbed out (for fear of a beating) before my question was given in. After learning figures as far as Fractions & Decimals &c, I was then put to learn Latin and in this I was for sometime complimented by my Master for the great progress I was making – but as I never knew for what purpose it was that I was put to learn it, & was wearied out with getting off long Tasks, I rather flagged in this department of my Education, and the margins of my Books and every space of spare & blank paper became filled with various kinds of devices or scenes I had met with & these were often accompanied with wretched Rhymes explanatory of them; but as I soon filled all the blank spaces in my Books, I had recourse, at all spare times to the Grave Stones & the Floor of the Church Porch, with a bit of Chalk to give vent to this propensity of mind of figuring whatever I had seen – at that time I had never heard of the word 'drawing' being made use of, nor did I know of any other paintings, besides the Kings Arms in the Church, & the Signs in Ovingham of the Black Bull, the White Horse, the Salmon & the Hounds & Hare – I always thought I could make a far better hunting Scene than the latter, the others were bejond my hand – I remember once of my Master's overlooking me while I was very busy with my chalk in the Porch, and of his putting me greatly to the blush, by ridiculing & calling me a conjurer – My Father also found a deal of fault for 'misspending my time in such idle pursuits', but my propensity to drawing was so routed, that nothing could deter me from persevering in it – and many of my evenings at home, were spent in filling the flags of the Floor & the hearth stone with my chalky designs – After I had long scorched my face, in this way, a friend, in compassion, furnished me with a lot of paper, upon which to execute my designs – here I had more scope – pen & Ink and the juice of the Brambleberry made a *grand change* – These were succeeded by a Camel hair pencil & Shells of colours & thus supplied I became completely set up – but of Patterns or drawings I had none – the Beasts & Birds which enlivened the beautiful Scenery of Woods &

Wilds, surrounding my native Hamlet, furnished me with an endless supply of Subjects. I now, in the estimation of my rustic Neighbours became an eminent Painter, and the Walls of their Houses were ornamented with an abundance of my rude productions, at a very cheap rate – These chiefly consisted of particular Hunting scenes, in which the portraits of the Hunters, the Horses & of every Dog in the Pack, were in their opinion, as *well as my own*, faithfully delineated. – But while I was proceeding in this way, I was at the same time deeply engaged in matters nearly allied to this propensity for drawing – for I early became acquainted, not only with the History & the character of the domestic Animals, but also with those which roamed at large.[1]

2: Cherryburn, Bewick's birthplace, viewed from the orchard at the back
of the house and looking to the west. Drawn and engraved by John Bewick
in 1781 and later finished by his brother. $3 \times 4\frac{3}{4}$ in.

The influence of Bewick's country boyhood was powerful, and the continued connection with the family tenancy of the small eight-acre farm of Cherryburn and its neighbouring colliery, fourteen miles west along the river Tyne from Newcastle, was crucial to the stimulation of his genius throughout his life. While the countryside and its inhabitants gave inspiration to the visual aspects of his work, his strict upbringing and particularly his schooling under the Revd Christopher Gregson at Ovingham vicarage, gave him the rigorously moral outlook on life which became the source of his inclination to instruct. From this also came his passion for the fable and its moral application – seen so clearly in the narrative tail-pieces with which he was later to enliven his own books of natural history.

In 1767, family connection brought him to an apprenticeship with Ralph Beilby, at that time the only

[1] *Memoir*, pp.4–5.

general engraver working in Newcastle. It was great good fortune for Bewick, for Beilby was one of a talented family of artist-craftsmen and was himself, as his apprentice put it, 'one of the best for learning young men'. He took in every kind of work, coarse or fine and was able to turn his hand to anything – making his own special tools whenever they were needed. His apprentice learned to do the same.[1] The engraving was predominantly on metal – on both the precious metals of the jeweller and silversmith, and on the working

steeple equal 40°, and from another window 18 feet directly above the former, the same angle was 37° 30′: What then is the height and distance of the steeple?

From LC = 40° 00′
Subt. LD = 37 30
Rem. $LCBD$ = 2 30
$L DBC$ = 2° 30′ — 8·6396796
DC = 18 feet — — 1·2552725
$LCDB$ = 127$\frac{1}{2}$° or 52$\frac{1}{2}$° — 9·8994667
CB — — — 2·5150596

3: A figure from Hutton's *Treatise on Mensuration*, 1768–70, one of the first jobs on which Bewick worked when an apprentice. 8$\frac{3}{4}$ × 6$\frac{1}{2}$ in.

metals of the mould-maker and printer. In proportion to the rest of the business the amount of wood engraving was very small. The first block Bewick would have seen cut was put in hand during the second week of his apprenticeship when 'the Arms of Newcastle' were engraved[2] – perhaps for a newspaper, and it was the only work on wood commissioned during that week. In the fifth week of his time, the mathematician Dr Charles Hutton brought the first extensive run of wood-block work to the shop, but being simple line diagrams for a book on mensuration [Fig. 3] they provided little more than an exercise in care and accuracy for the young apprentice.[3]

[1] *Memoir*, p.38ff. [2] Weekly Engraving Book 1766–8, 12–19 October 1767 (Laing Gallery, R.19). [3] Ibid., 26 October – 2 November 1767: '6 Geometrical Cuts at 4d'. Hutton's account of his connection with Bewick was published in the *Newcastle Magazine*, June 1822, pp.321–2. His *Treatise on Mensuration* began publication in parts in 1768.

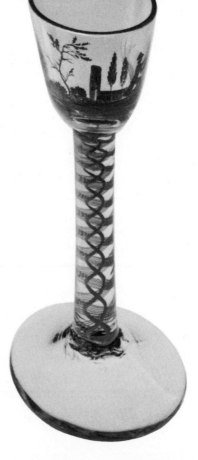

4 and 5: Two copper-engraved bookplates from the work-shop: for Mary Tunstall of Wycliffe (British Museum), and for John Brand, the antiquary, signed by Ralph Beilby (from the impression in Boyd's *Bewick Gleanings*, 1886). Both are typical of the vignette convention that influenced Bewick as an apprentice.

6: A wine glass decorated with a vignette in enamel by the Beilbys, *c.*1770. (Long loan to the Laing Gallery)

7: Two engravings by Bewick for the story of *Little Red Riding Hood*, *c.*1774.

132 FABLES.

FABLE XLIV.

The HOUND *and the* HUNTSMAN.

IMpertinence at firſt is borne
 With heedleſs ſlight, or ſmiles of ſcorn;
Teaz'd into wrath, what patience bears
The noiſy fool who perſeveres?
 The morning wakes, the Huntſman ſounds,
At once ruſh forth the joyful hounds.
They ſeek the wood with eager pace,
Through buſh, through brier, explore the chace:
Now ſcatter'd wide, they try the plain,
And ſnuff the dewy turf in vain.

<div align="right">What</div>

8: 'The Hound and the Huntsman' engraved by Bewick for *Fables by the late Mr Gay*, T. Saint, Newcastle, 1779. One of the cuts which secured a premium from the Society for the Encouragement of Arts in 1776.

9: Two early drawings by Bewick, inscribed by his daughter Jane. (British Museum)

Of formal training in draughtsmanship there appears to have been none beyond the exercise of copying from Copeland's *Ornaments*.[1] But as we have seen Bewick's hand and eye had already been spontaneously active in his early youth and the work coming in to the shop in great variety would have stimulated his skills as a designer. Beilby's brother and sister, William and Mary, were greatly accomplished enamellers of glass and their decorative vignettes and heraldic work would likewise have been sources of inspiration.[2] The influence of the workshop's great diversity of customers, many of them men of talent and learning, was particularly valuable, and through his contact with them Bewick was encouraged in his reading and in the widening of his knowledge.

During the second half of his seven-year term as apprentice, Bewick began to work on the design and engraving of wood blocks for a number of children's story books published by Thomas Saint and William Charnley in Newcastle, and some of these, which he produced for a series of fables eventually published by Saint in 1776, won him a prize awarded by the Society for the Encouragement of Arts Manufactures and Commerce. While no drawings directly associated with these books appear to have survived, the two reproduced here [Fig. 9] belong to a small group that seem to be relics of this early period. They show the beginning of his delight in landscape and the vignette form, and the decorative use he made of foliage. A few other early drawings, tiny and closely observed, of the heads of soldiers [Fig. 11] may have been taken while he was on a walking tour in Scotland after the end of his apprenticeship. This quick, miniscule note-taking continued throughout his life. His workshop accounts and his letters contain a number of delightful examples [Fig. 10]; and his friend Dovaston wrote of this trait in a memorial tribute: 'There were three windows in the front room, the ledges and shutters whereof he had pencilled all over with funny characters, as he saw them pass to and fro, visiting the well. These people were the source of great amusement: the probable histories of whom, and how they came by their ailings, he would humorously narrate, and sketch their figures and features in one instant of time. I have seen him draw a striking likeness on his thumb-nail, in one moment; wipe it off with his tongue, and instantly draw another.'[3]

The Scottish expedition over, and not wanting to set up in direct rivalry to his former master, Bewick took himself off to London, where indeed he could have secured enough work to keep him all his days. But despite the opportunities offered by the far wider circle of acquaintance amongst fellow artists and engravers, he found the city's ways hard to bear and he sorely missed his native countryside. Within nine months he was back in Newcastle and working in a partnership with Ralph Beilby that continued for twenty years, from 1777 to 1797. This period was to see the production and publication of the *General History of*

[1]Copeland's *New Book of Ornaments*, 1746; or the same by Lock and Copeland, 1752. Both editions were in the Bewick family sale of 1884. Copeland and Lock produced most of the designs for Chippendale's *Cabinet Maker's Directory*, 1754. [2]See James Rush, *The Ingenious Beilbys*, 1973, for fine colour plates of Beilby glass. [3]J.F.M. Dovaston, 'Some Account of the Life, Genius and Personal Habits of the late Thomas Bewick', in Loudon's *Magazine of Natural History*, March 1830, p.98.

10: Bewick's thumb-nail sketch of his son Robert playing the Northumbrian small-pipes – typical of many in the workshop records. (Cash Book R 39, Laing Gallery, slightly enlarged)

11: A group of early drawings by Bewick, probably made during his walking tour of Scotland in 1776, after the end of his apprenticeship and shortly before leaving for London. (British Museum)

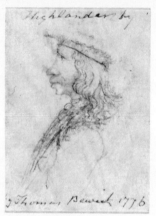
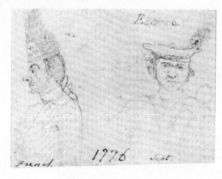

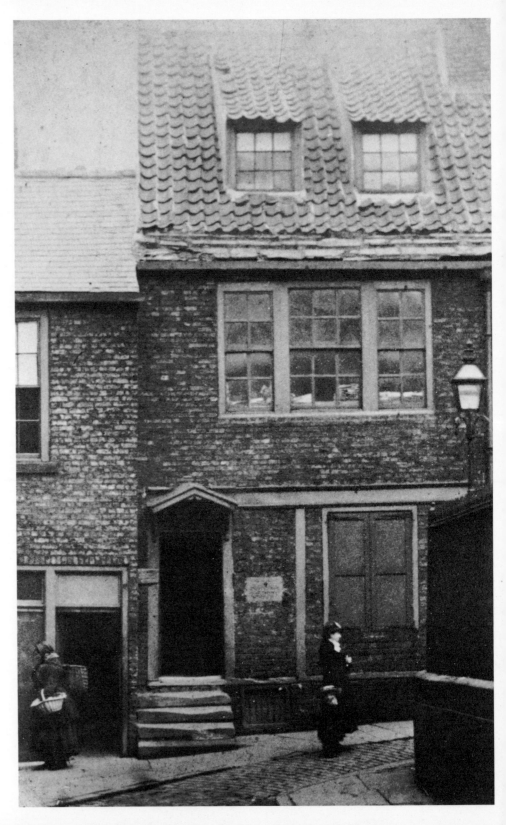

12: Beilby and Bewick's final workshop, built in 1790 in the south-east corner of St Nicholas' Church-yard. Photographed in the latter part of the nineteenth century. The building was demolished in 1903. (B. Collingwood Stevenson). The engraving was cut by the apprentice John Jackson for his *Treatise on Wood Engraving*, 1839.

HOWSON
Sadler & Cap-maker
RICHMOND
Yorkshire,
late Foreman to Mr. Raithby
Hyde Park Corner
LONDON.

a

b

Black Bull Wooler

13: A group of jobbing engravings by Bewick.
a. Copper-engraved trade card.
b. Copper-engraved vignette for pottery transfer. (British Museum)
c. Wood-engraved inn-keeper's bill-head.
d. Wood-engraved tobacco paper. (British Museum)
e. Wood-engraved masthead for the *Carlisle Journal*.

FINE
VIRGINIA

d

The
AND NORTHERN LITERARY INTELLIGENCER
Carlisle Journal

e

[21]

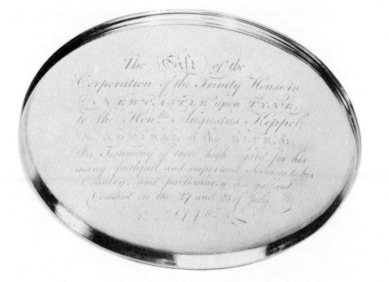

14: Gold Freedom Box, Newcastle upon Tyne *c.* 1779, presented to Admiral Keppel by the Corporation of the Trinity House of Newcastle. Engraved in the Beilby-Bewick workshop. $4\frac{1}{2}$ inches in length. (Laing Gallery)

15: An original copper-plate and a modern impression, etched and engraved by Bewick for Samuel Beardsley, inn-keeper, Ferryhill, 1803. $6 \times 3\frac{1}{2}$in.

Quadrupeds, 1790, and the first volume of the *History of British Birds*, 1797, and it brought to a full flowering his genius as a wood engraver.

The extraordinarily rich archive of workshop documents that records the time of this partnership, shows that the variety of commissions taken on was no less than it was in the time of Bewick's apprenticeship. Bewick himself, when answering the letters of impatient subscribers to his books, on more than one occasion spoke of his being delayed in his real interests by having 'to work for the kitchen'.[1] Throughout his life the engraving for these had to be given second place and much of it was held over for the evenings when the essential labour of the day was done.

We know that the idea for producing a natural history for the 'rising generation' was long germinating:

Having from the time that I was a school Boy, been displeased with most of the cuts in children's book, & particularly with those of the 'Three Hundred Animals'[2] the figures of which, even at that time, I thought I could depicture much better than those in that Book; and having afterwards, very often turned the matter over in my mind, of making improvements in that publication – I at last came to the determination of commencing the attempt. The extreme interest I had always felt in the hope of administering to the pleasures & amusement of youth & judging from the feelings I had experienced myself that they would be affected in the same way as I had been, this whetted me up & stimulated me to proceed – in this, my only reward besides, was the great pleasure I felt in imitating nature ... – Such Animals as I knew, I drew from memory upon the Wood

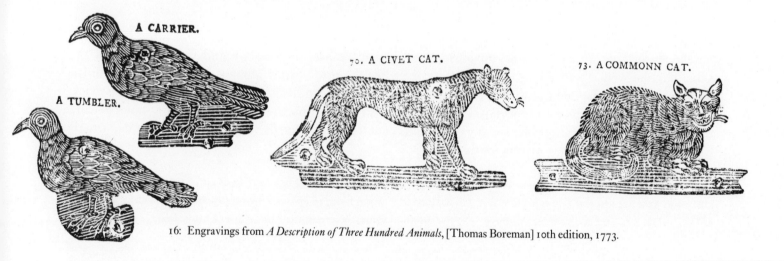

16: Engravings from *A Description of Three Hundred Animals*, [Thomas Boreman] 10th edition, 1773.

[1]TB to anonymous correspondent, n.d. [after 1790, before December 1795, Draft MS] (Editor's Collection). [2]Many editions were published during the eighteenth century. The earliest copy in the British Library is dated 1730.

– others, which I did not know were copied from D^r Smellie's abridgement of Buffon[1] & from other naturalists, & also from the Animals which were, from time to time, exhibited in Shows. I made sketches, first from memory, & then corrected & finished the drawings upon the Wood, from a second examination of the different subjects. . . .[2]

The *Description of Three Hundred Animals* by Thomas Boreman to which Bewick refers at the beginning of this passage, had reached its tenth edition in 1773, the fifth year of Bewick's apprenticeship. It is not hard to see why he thought he could do better [Fig.16]. The engravings were most crudely cut on copper plates, but for printing in relief; their crudity was further emphasised by the heads of the nails used – quite at random – to fix them to the wooden mounts that raised them to the height of the accompanying printing type.

The year 1781 provides us with the earliest record yet found that relates to the preparation of the *Quadrupeds*. Whether or not the publication of Thomas Pennant's book of the same title in this year, was the final spur, or mere coincidence, we find Bewick himself – not Beilby, the generally acknowledged compiler of the text – writing to Squire Fenwick of Bywell asking for information on his famous racehorse 'Match'em': 'An anxious desire for Information has prompted me to take the Liberty of troubling you . . . – We intend, in a little time, to publish a natural History of Quadrupeds and as the Horse, is the first which we shall begin with, we wish to relate as many authentic Anecdotes, as may be thought curious, *of that Noble Animal* . . .'.[3]

Bewick clearly drew on many sources for his text as well as his drawings. A number of other letters and notebooks survive which prove his anxiousness to secure the best information and visual references and show how he went about doing so. As we have seen, for the more exotic animals, he had recourse to the menageries of the day, and of this his correspondence with his brother tells us a good deal. John Bewick, having served five years of an apprenticeship in the workshop, went south to London and continued to work there for the rest of his short life, serving as a useful contact with the engraving trade and the wider artistic world. In 1787 Thomas was writing south:

I am very desirous to have your sentiments of the Animals w^{ch} I fancy you have seen in the Tower[4] before this time compared wth the prints &c you may have seen of them . . . – you cannot conceive to what pitch of anxious curiosity my imagination was wrought up to upon seeing proposals for publishing a series of Animals *after Nature* by Charles Catton Jun^r[5] – each N^o price

[1] George Louis Le Clerc, Count de Buffon, *Natural History general and particular . . . with occasional notes by the translator* [William Smellie], 9 vols, Edinburgh, 1781–5. [2] *Memoir*, pp.105–6. [3] TB to William Fenwick, 10 November 1781, Draft MS (Collection Mr Greer Allen). [4] A menagerie was first established in the Tower of London during the reign of Henry III, though it appears that a greater variety of animals beyond lions, tigers and leopards, was not assembled there until the eighteenth century. [5] C. Catton, *Thirty-six Animals drawn from Nature and engraved in aquatinta*, 1788: Catton was the son of the Royal Academician of the same name. Born in 1756, he later emigrated to America where he died in 1819.

17: An early prospectus for the *History of Quadrupeds*, 1788. $8\frac{1}{2} \times 9\frac{3}{4}$ in. Issued two years before the publication of the book. ▷

Newcastle, April 2, 1788.

PROPOSALS

FOR PUBLISHING BY SUBSCRIPTION,

A General History of Quadrupeds,

CONTAINING

A concise Account of every Animal of that Kind hitherto known or described.

WITH

Observations on the Habits, Faculties, and Propensities of each CREATURE.

INTENDED AS

A complete Display of that Part of Animated Nature,

At once Useful, Instructive, and Entertaining.

EMBELLISHED WITH

Accurate ENGRAVINGS on WOOD

OF EACH ANIMAL,

Drawn from the Life, or copied from the Productions of the best Authors on that Subject.

To the PUBLIC.

TO add to the Number of Publications already extant on this Branch of Natural History, may seem at first View both presumptuous and unnecessary; but when it is considered that the great Expence of the more voluminous Works confines them chiefly to the Libraries of the Wealthy, and that the smaller Publications of this Sort are such mean and pitiful Productions as must disgust every Reader of common Observation, the Propriety and Usefulness of this Undertaking will appear sufficiently obvious.

The great Care that has been taken to give the true Portrait and Character of each Creature, and the masterly Execution of the WOOD-ENGRAVINGS, will, it is hoped, strongly recommend this Work to every Admirer of that Part of Nature's Productions. Many of the Animals have been accurately drawn from Nature; and, in this Respect, the Editor has been peculiarly fortunate, in being enabled to offer to the Public more faithful Representations of some rare Quadrupeds than have hitherto appeared.

*** The Work will be neatly printed, in One Volume Octavo, on a good Paper, with entire new Types.

§†§ Price to Subscribers, *Eight Shillings* in Boards—To be paid on Delivery.

Printed for S. Hodgson, Bookseller, and Beilby & Bewick, Engravers, by whom Subscriptions are taken in; also by W. Charnley, R. Fisher, D. Akenhead, J. Atkinson, E. Humble and J. Whitfield, Newcastle; L. Pennington, Durham; J. Graham and T. Reed, Sunderland; R. Christopher, Stockton; W. Gray, Nottingham; W. Tesseyman and J. Todd, York; and W. Creech and C. Elliott, Edinburgh.

☞ Those Subscribers who wish to have their Copies on Royal Paper are requested to signify their Intentions to the Publishers.

15s to contain 6 Animals &c I waited for that No with great impatience & was greatly disappointed when I saw it . . . – I am much at a loss for want of a peep at the Tower &c – and am obliged to do the greatest part of the Animals I have done from memory –.[1]

John replied on 7 June:

I have not yet seen anything in the Animal way that I like so well as your own drawing, I have not seen the Museum, or Tower yet, but if I thout I could be in any service to you I would with the greatest pleasure . . .[2] – I have been twice seeing the Exhibition,[3] Mr Pollard and I was their the day after he arrived it was a grand sight to me, tho many people say its not a splendid one this year as has been formaly, – there was a Horse & Dog done by one Garrard which surpasses every thing I ever saw in my life I could have lookd at it for a week, there were several Horses by Stubs & two Buls fighting[4] which in my opinion were not very capital.–[5]

In January 1788 Bewick wrote again to his brother: '. . . I am obliged to you for the drawing of the Lion, Mr Edwards[6] says it is a faithful representation . . .'.[7] This was in response to John's letter of the previous November:

I saw Mr Mylock at Bartholomew Fair[8] but he would not part with his Print, so I bought one the same which I've sent you; but the Legs of the Lion I think are too short, they are much shorter & thicker than these in the Tower, – these two sketches are as near as I can draw from nature, the old Lion has very little shag about him, & that of the young one particularly the part under his belly is intirely Caked together in flat pieces the size of the palm of your hand, which appears rather ugly, whether they are so in their wilde state or no I cannot say, their is no long hair at the end of the Tail, – they have not got a Wolf in the Tower at present, but I saw two at Barthw Fair, but they appeared to be only wolf dogs & seemed quite tame. I show'd yours to the man at the Tower, he say'd he was too much like a Bullock, I think myself he is clumsy & heavy & his ears are the one half too short but if possible I will get a real sketch.[9]

Bewick later wrote to his brother with news of a travelling menagerie:

I wish I had as good a [representation] of the Wolf, the form and shape of which is so variously and contradictorily repre- sented to me by different people that I am quite puzzled as to its real appearance . . . I am glad to find that a large collection of

[1] TB to John Bewick, n.d., Draft MS (Editor's Collection). [2] Although not mentioned in any surviving correspondence John Bewick may have visited the animal collections of Dr John Hunter, the surgeon and anatomist. [3] At the Royal Academy. [4] 'Bulls Fighting' dated 1787, by George Stubbs, is now in the collection of Mr Paul Mellon. The work by Garrard referred to is probably the 'Bay Cob and a Terrier by a Stable', dated 1787, and now also in the same collection. [5] TB from John Bewick, 7 June 1787 (Collection Mr Bewick Hack). [6] Edward Edwards A.R.A., 1738–1806. He was at the time painting the scenery in the Newcastle theatre. His *Anecdotes of Painters*, published in 1808, is now his chief memorial. [7] TB to John Bewick, 9 January 1788 (Pease Collection). [8] Bartholomew Fair opened every year at Smithfield on 3 September. A great national fair, particularly for the sale of livestock, accompanied by entertainments and amusements, it was last held in 1855. [9] TB from John Bewick, 1 November 1787 (Collection Mr Bewick Hack).

animals is now on its way to this Town. They are expected here at the latter end of this month. They consist of various kinds of the Ape tribe, Porcupine, Tiger-cat, and Tiger, Greenland Bear, and one of the finest Lions, very lately brought over, that ever made its appearance on this Island, so I expect to have the opportunity of doing such of them as I want, from the life.[1]

Evidence of another source of live originals occurs in a letter of Bewick's boyhood friend Robert Pollard, also established in London as an engraver. He wrote in October 1789:

Having rec[d] intelligence that the late Transport ships which have arrived from Botany Bay have brought over some Natural Curiousities & among the Rest a Native of the Dog Specious I was inform'd of it by an Artist that had been to draw it (I believe to engrave) & it having immediately occurred to me that it would be a good subject for y[r] Natural History if the Work is not finished if you approved of the Hint & is desirous of a sketch I can procure it for you or point out to y[r] Broth[r] John where its to be seen...[2].

Two years in advance of publication a prospectus was issued which displayed three of the engraved figures [Fig.17] and it provoked some severe criticism from John:

I rec[d] yours by favour of M[r] Northley with the proposals, the execution of which I think incomparable, but as to the Printing of them I'll say nothing, – I was exceedingly sorry, & vext, to see your Hyæna done without a tail, an Animal so particularly well known among the curious, I should thout you might have seen Mr Cattons, which is a pretty good one...[3].

The success of the *Quadrupeds* was immediate. A second printing followed almost at once, and by 1824 there had been eight successive editions. The letter Bewick received from Matthew Gregson, a Liverpool upholsterer and a fairly regular correspondent, was typical of the general response:

I cannot without much violence to my own Inclinations avoid acknowledging the very great satisfaction I received on Viewing the Small Prints in the History of Quadrupeds in which you have so distinguished yourself, – I confess they are much superiour to any thing that has lately been seen in this way and what I had given up all hopes of ever seeing.... The general Effect, the Distances all are excellent and I know these are the Sentiments of a Society of Gentlemen here under the name of the *Print Society*, who have formed themselves for the Purpose of Purchasing Prints & meet occasionally to view & discourse about Prints, of which Society I have the honour to be a member ... your work was mentioned with much pleasure & received from all the highest Encomiums of Praise for the Improvements you have made in this branch of the Graphic Art.[4]

The briefest comparison of Bewick's work with that of his predecessors and contemporaries makes very plain its freshness and originality. The copper engraving of the Cougar by his London employer Isaac Taylor

[1] TB to John Bewick, 9 January 1788 (Pease Collection). [2] TB from Robert Pollard, 24 October 1789 (V & A). This animal probably provided the figure for the New South Wales Wolf. [3] TB from John Bewick, 29 May 1788 (Collection Mr Bewick Hack). [4] TB from Matthew Gregson, n.d. [before 29 March 1794] (Editor's Collection).

A GENERAL
HISTORY
OF
QUADRUPEDS.

THE FIGURES ENGRAVED ON WOOD BY T. BEWICK.

NEWCASTLE UPON TYNE:

PRINTED BY AND FOR S. HODGSON, R. BEILBY, & T. BEWICK,
NEWCASTLE: SOLD BY THEM, BY G. G. J. &
J. ROBINSON, AND C. DILLY, LONDON.

1790.

18: A title-page (reduced) and an opening from the first edition of the
History of Quadrupeds, 1790.

THE SPANISH POINTER

is of foreign origin, as its name seems to imply; but it is now naturalized in this country, which has long been famous for Dogs of this kind; the greatest attention being paid to preserve the breed in its utmost purity.

This Dog is remarkable for the aptness and facility with which it receives instruction: It may be said to be almost self-taught; whilst the English Pointer requires the greatest care and attention in breaking and training to the sport. The Spanish Pointer, however, is not so durable and hardy, nor so able to undergo the fatigues of an extensive range. It is chiefly employed in finding partridges, pheasants, &c. either for the gun or the net.

It is said, that an English nobleman (Robert Dudley, duke of Northumberland) was the first that broke a Setting-Dog to the net.

Many of the Setting-Dogs, now used by sportsmen, are a mixt breed, between the English and Spanish Pointer.

THE

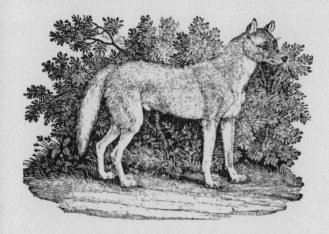

THE NEW SOUTH-WALES DOG

is of a very favage nature. It neither barks nor growls; but when vexed, erects the hairs of its whole body like briftles, and appears extremely furious.—It is fond of rabbits and chickens, which it eagerly devours raw; but will not touch dreffed meat.——Its great agility gives it much the advantage over other animals fuperior in fize. One of them, fent to this country from *Botany-Bay*, was fo extremely fierce, as to feize on every animal it faw; and, if not reftrained, would have run down Deer and Sheep: An Afs had alfo nearly fallen a victim to its fury.

The height of this fpecies is rather lefs than two feet; the length two feet and a half. The head is formed much like that of a Fox; the ears fhort and erect. The general colour is a pale-brown, lighter on the belly; the feet and infide of the legs white. The tail is rather long and bufhy, fomewhat like that of a Fox.

We

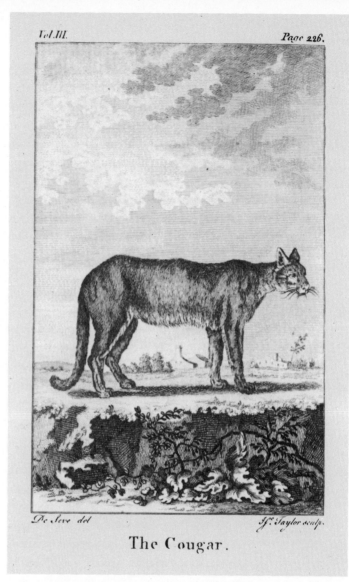

Vol. III. *Page 226.*

De Seve del *If. Taylor sculp.*

The Cougar.

19: An illustration from Goldsmith's *History of the Earth, and Animated Nature*, 1791. Engraved on copper by Isaac Taylor, who gave Bewick employment during his brief stay in London. It conveys some idea of how startlingly fresh Bewick's work would have appeared when first published

shown here [Fig.19] with Bewick's wood engraving provides us with some typical evidence. The strongest factor behind his success as a wood engraver lay in the autographic nature of his work. He was blessed with the true painter's eye and observed his subjects with great clarity and portrayed them with equal faithfulness. In the *Quadrupeds* his most felicitous subjects are to be found amongst the domestic and semi-domestic animals – the horses, dogs, cattle and sheep, and others which he had had the best opportunity to observe over an extended period. The profile portrait, essential for recognition in a work specifically designed to inform and instruct, was nevertheless very often provided with an appropriate and beautifully observed landscape background, and sometimes, as in the case of the Mastiff (Vol.1, p.109) or the Harrier (Vol.1, p.111) the background was filled with tiny animated figures which even on so small a scale captured the animal's manner and habits superbly well.

Some of the rarer subjects retain the awkwardness of the original paintings or engravings of them to which Bewick was forced to refer, such as his Kangaroo after the painting by Stubbs. Yet his 'Spanish Pointer', so often admired, owes everything to the fine engraving by Woollett after Stubbs which hung in his parlour for many years.[1]

Of the truthfulness of Bewick's eye in his animal portraiture we find some evidence in his dealings with the local stock breeders. Anxious for portraits of their prize animals, and conscious of the points considered desirable in prize specimens, they wanted such features if not exaggerated, at least more than usually prominent. Bewick was unable to compromise with what he saw in the animals and thus lost himself several commissions.[2] The portrait of Thomas Smith's Cheviot Ram (Vol.2, p.225) seems to have been one of the exceptions that passed the owner's test.

... I was sent for to go to Darlington & thence to Barmpton, to make drawings of Cattle & sheep to be engraved for a Durham Report. – After I had made my drawings, I soon saw, that such as I had made from the fat Sheep, were not such as were wanted, but these were to be made like the *such & such* paintings as were shewn to me – I observed that these paintings were nothing like the animals whose Figures I had made my drawings from & that I would not alter mine to suit the paintings that were shewn to me nor put my name to such – but if it were wished that I should make engravings from these paintings, I had not the slightest objection to do so, & that I would also endeavour to make fac similes of them – but this proposal would not do – and my journey, as far as concerned these fat Cattle makers, ended in nothing – I would not put lumps of fat here & there to please them where I could not see it – at least in so exagerated a way as on the painting before me – so I got my 'labour for my trouble' – many of the Animals were, during *this rage* for fat Cattle, surely fed up to as great a weight & bulk, as it was possible for feeding to make them but this was not enough, they were to be figured monstrously fat before the owners of them could be pleased....[3]

[1] Several wood-engraved versions of Stubbs's 'Pointer' are found in nineteenth-century books, all of them probably taken from Bewick's vignette. [2] Letters to TB from R. Colling, Barmpton, May 1799 (Editor's Collection). [3] *Memoir*, pp.140–1.

It has been said that for most of Bewick's work on the *Quadrupeds* there were no preliminary drawings on paper and that all the preparation was applied directly to the wood block surface.[1] In fact more than seventy pencil drawings for the book have survived which relate to all its parts,[2] so it is reasonable to assume that many more were destroyed. It is plain to see from those that have survived that the outline was the most significant feature to be recorded on paper and that virtually all the development of texture and detail was kept for execution directly on the block surface. There is only one coloured drawing of a quadruped to be found in the collections and this was for a much later edition – published after Bewick had been making use of colour for several years.

There are few larger drawings of animals unrelated to the engravings for the *Quadrupeds*, but the fine Tiger now in the Laing Gallery (Vol.1, pp.122–3) may have had some connection with the four large prints of the Tiger, Lion, Zebra and Elephant, engraved for Gilbert Pidcock in 1799. Pidcock kept the menagerie at Exeter 'Change in London. He travelled his 'wild beast show' round the country and was clearly one of Bewick's sources for the more exotic subjects. The large prints were probably intended mainly for separate sale, though Hugo records a collected issue in stiff covers with a York imprint dated 1800. It is also possible that the blocks were used in Pidcock's handbills and posters.

Another large drawing is of particular interest in that it was done directly on a lithographic stone and it was Bewick's only essay in the medium. His account of this as related to John Dovaston provides further evidence of his searching eye:

– As you wish me to tell you all about the Lithographic Fig: of the Horse, I did in Edin.^r I can only say that, when in Ballentine & Robertson's Printing Office they urged me, very pressingly to give them a design – this on the Wednesday and as our departure being fixed for the Friday, I declined acceeding to their request – they however sent up the Stone that Evening & Jane Bewick also urged me, so pressingly, to undertake it, that I fell to work with it next morning & finished it before breakfast, – in the slight manner you see – and by the afternoon they had taken several Impressions – one of which it seems had been sent to you – my reason for fixing upon that particular design was to pourtray, as well as I could, the motion of a Horse in the long or full trot, & to shew it to a very ingenious painter (in Edinburgh) & excentric man of the name of Howe, who had been labouring in vain like thousands, perhaps, of other painters to give a representation of motion in Animals, this led to a close conversation, or lecture on the subject, in which I convinced him thoroughly of his being quite wrong, & indeed of the absurdity of his drawings, in this respect. I pressed him to endeavour to become master of this very difficult part of his Art, and I daresay he will attempt most anxiously to do so – I told him I had always endeavoured to give the proper motion to animals, but was never satisfied with my own performances, neither did I recollect of ever having seen any that were any thing like correct – It may perhaps amuse you to look at a Horse either galloping or trotting – in the first, you will find he does not, nor can he, throw his feet so far forward as his nose – in the latter action you will see that his knees do not appear

[1] D.C. Thomson, *The Watercolour Drawings of Thomas Bewick*, 1930, p.66. [2] Pease Collection: an album of original drawings and letters, No.174.

20: 'The Cadger's [Travelling Hawker's] Trot', 1823. 6½ × 8in. One of about twenty impressions of Bewick's only essay in lithography.

further forward than his breast – if time permitted, a great deal more might be said, on this subject – what passed between my new acquaintance & me, I am told prevented his sleeping . . .[1].

These observations seem to have come to Bewick fairly late in his career, and while he successfully captured the nature of the horse's diagonal action in the trot, the gallop seems to have eluded him.

The idea of preparing a book on birds was an obvious sequel to the publication of the *Quadrupeds* and not long afterwards we find the subject brought up in a letter Ralph Beilby wrote to Bewick, who was at the time on holiday at Tynemouth: '. . . Have had a letter from M[r] Tunstal who says Sir J[os] Banks is very desirous that we should go on with the Birds, I believe we must think of it seriously, can you get hold of any *Aquatics* whilst at Tynmouth?'[2] The genesis of the book is of course given some prominence in Bewick's *Memoir*:

–While the sale of the Quadrupeds was going on, Edition after Edition with great success – I turned my thoughts to the History of British Birds. With these, I had long felt *greatly* charmed, paid great attention to, and busied myself very much in reading various descriptions or accounts of them – the first, (as far as I can now recollect) was Brookes and Miller's 'Natural History'[3] & D[r] Smellies abridgment of Buffon[4] – these, which were now thrown, as it were, in the background, was succeeded by Pennants Works[5] – first & last, I might name many others, which I had perused – chiefly lent to me by [my] kind friend George Allen Esq[r] – those consisted of Albins 'History of Birds'[6] – Belon's very old Book,[7] & 'Willughby & Ray'[8] &c and M[r] John Rotheram gave me Gesner's Natural History.[9] With some of these I was in raptures – Willughby & Ray struck me as having led the way to truth and to British Ornithology – The late Michael Brian Esq[r][10] of London (formerly of Newcastle) lent me the splendid Volume (planches enluminees) of Buffon – & George Silvertop Esq[r] of Minsteracres, Edwards 'Natural History'[11] – I was much pleased with 'Whites History of Selburn'[12] – Pennants, however opened out the largest field of information, and on his works I bestowed the most attention. Latham seems to have wound up the whole,[13] and I have often lamented, that it was not, by being embellished with correct figures, made a great National Work like the Count de Buffon's — The last of our Ornithologists, and one of the most indefatigable, was the late Colonel George Montagu Author of the Ornithological Dictionary[14] — As soon as it was spread abroad, that we were engaged with the History of Birds & their Figures,

[1]TB to J.F.M. Dovaston, 26 February 1824 (British Library, Egerton MS 3147). [2]TB from Ralph Beilby, 31 [sic] September 1790 (Editor's Collection). [3]R. Brookes, *A System of Natural History*, 6 vols, 1763; John F. Miller, *Various Subjects of Natural History . . .*, 1785. [4]George Louis Le Clerc, Count de Buffon, *Natural History general and particular . . . with occasional notes by the translator* [William Smellie], 9 vols, Edinburgh, 1781–5. [5]Thomas Pennant, *British Zoology*, 1766; *A Synopsis of Quadrupeds*, Chester, 1771; *History of Quadrupeds*, 2 vols, 1781; *Genera of Birds*, Edinburgh, 1773; *Arctic Zoology*, 1784. Bewick wrote to a correspondent: ' – as I cannot depend upon any of M[r] Pennants Engravings – so far as I know his Birds they are incorrect both as to position & plumage & I wish as far as I am able to be faithful in both . . .' (TB to George Mark, painter, Darlington, 19 February 1794, Barnes Collection of letters, Pease Collection). [6]Eleazar Albin, *Natural History of Birds*, 3 vols, 1781, 1784 and 1788. [7]Pierre Belon, *L'Histoire de la Nature des Oyseaux avec leurs Descriptions, & Naifs Portraits retirez du Naturel*, Paris, 1555. [8]Francis Willughby, *Ornithology, translated into English and enlarged by John Ray*, 1678. [9]Conrad Gesner, *History of four-footed Beasts and Serpants, translated by E. Topsell*, 1658 [10]Michael Bryan, 1757–1821, connoisseur and author of the *Biographical and Critical Dictionary of Painters and Engravers*, 2 vols, 1813 and 1816. [11]George Edwards, *A Natural History of Uncommon Birds . . . Gleanings of Natural History*, 7 vols, 1743–64. [12]Revd Gilbert White, *The Natural History and Antiquities of Selborne in the County of Southampton*, 1789. [13]John Latham, *A General Synopsis of Birds*, 6 vols, 1781–5, with various supplements. [14]Col. George Montague, *Ornithological Dictionary; or Alphabetical Synopsis of British Birds*, 2 vols, 1802.

I was, in consequence, led into a seemingly endless correspondence with friends & amateurs in this way, so much so, that I often felt myself unable, duly to acknowledge the obligations I owed them – and many a letter I have written, after being so wearied out with the labours of the day, that I often forgot how to spell the very commonest words – & I fear the rest of many of my letters would be of a piece with this, and not clear nor very intelligible. – At the beginning of this undertaking, I made up my mind to copy nothing from the Works of others but to stick to nature as closely as I could – And for this purpose, I being invited by Mr Constable, the then Owner of Wycliffe,[1] to visit the extensive Museum there, collected by the late Marmaduke Tunstall Esqre, and to make drawings of the Birds – I set off from Newcastle on the 16 of July 1791 . . . & remained there, drawing from the stuffed Specimens, nearly two months – .[2]

Bewick's letter to Beilby, written while he was staying at Wycliffe, adds much detail and atmosphere to the retrospective account. It confirms his concern for accuracy and his dissatisfaction with indifferently set up specimens, and it also shows, contrary to his *Memoir*'s record, that he was prepared to consider using the engravings of other artists as models:

I arrived at this remote corner of the Earth on monday night last, and was kept busy for two or three days, 'till my Box arrived, in looking thro' *part* of the very rare and curious Books on natural Hisy with which this valuable Library I believe is more amply furnished than any other, I think one may venture to Say in the Kingdom – you would be amazed at M Tunstals industry – to skim over only his own remarks wou'd take a much longer time than I can possibly spare – he has not only put down every thing that came under his own observation on the habits & propensities of Animals &c. with numberless Anecdotes – but he has also quoted every thing that he thou't curious from other Authors – he has not even forgot *Beilby & Bewicks* Quads. & has discover'd all that we call new in our Book – & has placed the Cuts along with his remarks: – What a treasure would his remarks be of to us – we wou'd nead but little besides to enable us to give a *new Hist'y of Birds* if we cou'd get the loan of them – he has also a great number of well colour'd Birds placed in along with his own observations – I have look'd thro' Edwards, Buffon, Albin, Pennant, Lewen, Catesby, Brown & many others the grandest Editions – all colour'd – and I find that Edwards & Buffon are the only Books that will be worth any thing to us – I mean for the figures, which are generally extreemly well done, & indeed I think better to copy than the stuffd Birds here. I can only pay attention to the Beak & plumage – they are so distorted & unnaturaley stuck up that, as faithfull representations of them as I can do, appear stiff as a poker[3] – (as the Museum is to be sold[4] I wou'd not like to have it said that we said any thing slighting of it.) The Museum besides being stock'd with above 800 Birds, contains also a number of other things Beasts, Reptiles, Fishes, Insects &c. Mr. T spared no expence in obtaining everything that he thout curious especially on Nat.' Histy – I think he has been fondest of Birds, but perhaps, I may think so, from my paying more attention in that way than any

[1] William Constable of Burton Constable, Tunstall's half-brother, who survived him only six months. Edward Sheldon, Constable's nephew, inherited the property and sold the Museum to George Allan, of Darlington. [2] *Memoir*, pp.116–17. [3] Bewick told John Hancock that he had to draw a number of the subjects while standing on a ladder (MS notes of John Hancock, Natural History Society of Northumbria). What he did not remark upon, here or elsewhere, was the fact that some of his museum specimens may have suffered from fading in their colouring through too great an exposure to light. [4] See note 1 above.

21: A pair of untrimmed prospectuses for the first edition of Vol.1 of the *British Birds*, 1797. $9\frac{3}{4} \times 12$ in. ▷

HISTORY
OF
BRITISH BIRDS.

In a few Weeks will be publifhed,

THE FIRST VOLUME OF THIS WORK;

The Figures engraved on Wood by T. BEWICK.

Wove Demy 10s. 6d.—Royal (hot-preffed) 13s.—Super-Royal 18s.—
And a few Impreffions on Imperial Paper at One Guinea each.

Subfcriptions are taken in by the Authors, BEILBY and BEWICK,
Newcaftle upon Tyne; by G. G. and J. ROBINSON, London; and
by the principal Bookfellers in England.

HISTORY
OF
BRITISH BIRDS.

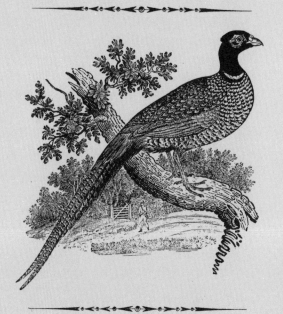

In a few Weeks will be publifhed,

THE FIRST VOLUME OF THIS WORK;

The Figures engraved on Wood by T. BEWICK.

Wove Demy 10s. 6d.—Royal (hot-preffed) 13s.—Super-Royal 18s.—
And a few Impreffions on Imperial Paper at One Guinea each.

Subfcriptions are taken in by the Authors, BEILBY and BEWICK,
Newcaftle upon Tyne; by G. G. and J. ROBINSON, London;
and by the principal Bookfellers in England.

other. Pennants Folio Brit. Zoology – describes about 220 – all British – Edwards with his gleanings contains 365 large Quarto plates, with severl Figs on some of them, amontg in the whole to 660 articles; all 'strictly drawn & colour'd from nature' – he says he was upwards of 20 years in collecting them – The number of Birds treated of by Linneus amounted to a few above 900 – 30 or 40 of which were new – Latham describes about 1000 – 5 or 6 hundred of which he says are only to be found treated of in his work — Thus have I given you a hasty outline of the business which I am upon – I shall get as many of the rarest British Birds as I can – I think we cannot in one Volume do more. . .[1].

The final plan for the *British Birds* probably took some time to resolve. In an undated letter to an unnamed correspondent Bewick wrote: 'I am very busily employ'd upon the Cuts for the intended History of Birds – but no plan is as yet fixed upon excepting that of publishing them in the same size & manner of the Quadrupeds – I have got a very large Collection of Drawings from nature – if, when they are all cut, it is found that they will not come into one Vol: – perhaps we may make two of it – perhaps the British Birds in one, & the foreign in the other. . . .'[2] To another unnamed correspondent Bewick wrote at some time after March 1794:

I was favour'd with your obliging letter of the 6 Inst requesting to know if the History of Birds of which you had seen some specimens was not yet published – I have had many applications of the same kind from all Quarters which makes me very desirous to have it done, but as I am obliged to attend to many jobs in the line of my Business which necessarily takes of my time & attention from it, I cannot say exactly when they will make their appearance in the World – the Cuts are in great forwardness but none of the tail pieces or vignettes are done yet 'tho I have about 50 designed ready to lay upon the wood – I have also lost a deal of time in drawing foreign Birds from Museums which will not be used in this Vol it being intended for a History of British Birds only & will be nearly on the same plan as the Quadrupeds –[3].

The difficulties Bewick found in securing drawings of sufficient accuracy is recorded in a further passage of his *Memoir*:

As soon as I arrived in Newcastle, I immediately began to engrave from the drawings of the Birds I had made at Wycliffe, but I had not been long thus engaged 'till I found the very great difference between preserved Specimens & those from nature, no regard having been paid at that time to place the former in their proper attitudes, nor to place the different series of the feathers, so as to fall properly upon each other. This has always given me a great deal of trouble to get at the markings of the dishevelled plumage & when done with every pains, I never felt satisfied with them. I was on this account driven to wait for Birds newly shot, or brought to me alive, and in the intervals employed my time in designing & engraving tail pieces or Vignettes. My sporting friends however supplied me with Birds as fast as they could. . . .[4].

[1] TB to Ralph Beilby, 24 August 1791 (Collection Mr Christopher Dobson). [2] TB to anonymous correspondent, n.d., MS Draft (Pease Collection). [3] MS Draft (Pease Collection). [4] *Memoir*, pp.121–2.

Given the circumstances of their production the two volumes of Bewick's *Birds* were an astonishing achievement. They stimulated his finest work as an engraver and secured his fame. By 1826 eight editions of the *Land Birds* and six editions of the *Water Birds* had appeared, and although they could not be priced within the reach of all who might have enjoyed and made use of them, their excellence reached and stimulated a wider section of the population than more expensive works that lacked the animation of Bewick's hand in their illustrations.[1] As an influence on the quickening interest in natural history, Bewick now ranked with that other remarkable observer of the natural scene, Gilbert White of Selborne. An interesting example of this was later recorded by Charles Kingsley who wrote to Jane Bewick in April 1867:

When your father's book on birds first came out, my father, then a young hunting squire in the New Forest, Hampshire, saw the book in London, & bought at once the beautiful old copy w^h was the text book of my boyhood. He as sportsman & field-naturalist, loved the book, & carried it with him up & down, in days when no scientific knowledge could be got – from 1805–1820; . . . he was laughed at in the New Forest for having 'bought a book about dicky birds' – till his fellow squires, borrowing the book of him – agreed that it was the most clever book they had ever seen, & a revelation to them. . .[2].

Bewick's friend George Allan the antiquary, who had become the owner of Tunstall's collections, wrote to him in 1797, after the publication of the first volume:

I received your parcell safe, and am in more raptures than I can possibly express in looking only cursorily over your ingenious Work, which will ever remain inimitable and the Standard of the Art, and I sincerely wish you a Tenfold recompence for all your labours. – As you say, some gaps remain to fill up among your Water Birds; I cannot refrain lending you every assistance in my power, & therefore you will receive herewith, Pennants Volume on that Subject, & also a descriptive Catalogue of all the Acquatic Birds in my Museum: From these, you may chance to find something worthy your Notice in these Notes, – many of them being M^r Tunstall's Observations. If you mean to make any additions to your 2^d Edition of the Land Birds – you are welcome to these Volumes. – At present, I am not in much want of these Books, tho' I am daily peeping into them; You will therefore return them as soon as you conveniently can. – My collection of the Water Birds, you will observe are numerous, & in living Attitudes; – I now flatter myself, that you will be induced to pay me a Visit to see them, where be assured of a most sincere & hearty Welcome to every thing this House can afford & as long as you please. – . . .[3].

Despite his whole-time commitment to his general engraving business what better encouragement could Bewick have wished for. The flow of correspondence from delighted naturalists was unceasing: suggestions for future works, specimens for drawing, information on breeding habits, questions relating to the identification of species, – the range of topics increased as the months passed. As he tells us, he had immense difficulty in keeping up with all the letters that poured in, but the response could never have been more gratifying.

[1] The quality of the engravings has in later times led many critics to expect too much of the text, forgetting the simple purpose of its authors. [2] Editor's Collection. [3] TB from George Allan, 13 November 1797 (Editor's Collection).

HISTORY

OF

BRITISH BIRDS.

THE FIGURES ENGRAVED ON WOOD BY T. BEWICK.

VOL. I.

CONTAINING THE

HISTORY AND DESCRIPTION OF LAND BIRDS.

NEWCASTLE:

PRINTED BY SOL. HODGSON, FOR BEILBY & BEWICK: SOLD BY THEM,
AND G. G. AND J. ROBINSON, LONDON.

[*Price* 10s. 6d. *in Boards.*]

1797.

22: The title-page (reduced) and an opening from the first edition
of Vol. 1 of the *British Birds*, 1797.

The characters of this genus with us are some-
what equivocal, and not well afcertained; neither
do we know of any common name in our lan-
guage by which it is diftinguifhed. Mr Pennant
defcribes it thus: " Bill flatted at the bafe, almoft
triangular, notched at the end of the upper mandi-
ble, and befet with briftles at its bafe." We have
placed the Flycatcher here, as introductory to the
numerous clafs which follows, to which they are
nearly related, both in refpect to form, habits, and
modes of living: The affinity between them is fo
great, as to occafion fome confufion in the arrange-
ment of feveral of the individuals of each kind, for
which reafon we have placed them together.

THE PIED FLYCATCHER.

COLDFINCH.

(*Muſcicapa Atricapilla*, Lin.—*Le traquet d'Angleterre*, Buff.)

LENGTH near five inches : Bill black ; eyes ha-
zel ; the forehead is white ; the top of the head,
back, and tail are black ; the rump is daſhed with
aſh colour ; the wing coverts are duſky, the great-
er coverts are tipped with white ; the exterior
ſides of the ſecondary quills are white, as are alſo
the outer feathers of the tail ; all the under parts,
from the bill to the tail, are white ; the legs are
black : The female is brown where the male is
black ; it likewiſe wants the white ſpot on the fore-
head. This bird is no where common ; it is in
moſt plenty in Yorkſhire, Lancaſhire, and Derby-
ſhire. Since the cut, which was done from a ſtuf-

nous tenons quelque petit chien pour cõpagnie,que faiſons coucher ſur les pieds
de noſtre lict pour plaiſir : iceluy y auoit telles fois quelque Lion, Once, ou autre
telle fiere beſte , qui ſe faiſoyent chere comme quelque animal priué es maiſons
des paiſants . Lon dit communement,que le Heron eſt viande Royale. Parquoy
la nobleſſe Françoyſe fait grand cas de les manger , mais encor plus des Heron-
neaux: toutesfois les eſtrangers ne les ont en ſi grande recommendation . Il ſont

Pellos & Herodios en Grec , Pella & Ardea en Latin, Heron en Francois.

O' το ω ει ιμαιδευ σπεφτω ηλίσε χαλεπτω ιννεξτει ξ̀, ηγμοί,κ̀,δ̀ξά τι γ̀ ὰ ϊ, αι εω,ιν εωτε λάριον, ιν τ̀ λαδω, μώι ηγμει,κ̀, ταλή φαιλωτ,κ̀, ιδωινφ,τω κρφδει β̀,σιαε μαιζμεί ξ̀ τοις δι ὰπ'εων ιειεω,ὰὶ τιλς β̀ δω.τι, κ̀ αλωιτωι. οὺλιε γ̀ αιντει ὲ ναιτις. κ̀ι τερφδη τι χαι δα ὰντι κλεψει ιωιὰς κ̀ιτε δ' ιτι κ̀ι δικντιδεε κ̀ι ιντερχει τω ιδ̀ντω χ̀ιμαι ὶγει τὼιλαι χ̀ τὼι τιλιει ὰὶ ιγεῖ. Ariſt. lib.9.cap.1.& 18.

ſans cõparaiſon plus delicats que les Grues.Il apert par le vol qu'on dreſſe main-
tenant pour le Heron auec les oyſeaux de proye, que les anciens n'auoyent l'art
de fauconnerie ſi à main comme on l'a maintenant. Ariſtote a bien dit , au pre-
mier chapitre, du neufieſme liure, que l'Aigle aſſault le Heron, & qu'il meurt
Combat en ſe deſſendant.Le Heron ſe ſentant aſſailly,eſſaye à le gaigner en volant con-
du Heron tremont,& non pas au loing en fuyant, comme quelques autres oyſeaux de riuie-
auec l'Ai re: & luy ſe ſentant preſſé,met ſon bec contremont par deſſous l'ælle,ſachãt que
gle. les oyſeaux l'aſſomment de coups,dont aduient bien ſouuét qu'il en meurt plu-
ſieurs

23: A page from Pierre Belon's *L'Histoire de la Nature des Oyseaux*,
Paris, 1555. Folio. The book was one of the sources for the compilation
of the text of the *British Birds*. (Natural History Society of Northumbria)

HISTORY

OF

BRITISH BIRDS.

THE FIGURES ENGRAVED ON WOOD BY T. BEWICK.

VOL. II.

CONTAINING THE

HISTORY AND DESCRIPTION OF WATER BIRDS.

NEWCASTLE:

PRINTED BY EDWARD WALKER, FOR T. BEWICK: SOLD BY HIM, AND
LONGMAN AND REES, LONDON.

[*Price 12s. in Boards.*]

1804.

24: The title-page (reduced) and an opening from the first edition
of Vol. 2 of the *British Birds*, 1804.

namenting the head-dreſſes of the European ladies,
and the turbans of the Perſians and Turks.

The Egret ſeldom exceeds a pound and a half
in weight, and rarely a foot and a half in length.
A bare green ſkin is extended from the beak to the
eyes, the irides of which are pale yellow: the bill
and legs are black. Like the common Heron they
perch and build their neſts on trees, and live on
the ſame kinds of food.

This ſpecies is found in almoſt every temperate
and warm climate, and muſt formerly have been
plentiful in Great Britain, if it be the ſame bird
as that mentioned by Leland in the liſt or bill of
fare prepared for the famous feaſt of Archbiſhop
Nevil, in which one thouſand of theſe birds were
ſerved up. No wonder the ſpecies has become
nearly extinct in this country!

BITTERN.

BOG-BUMPER, BITTER-BUM OR MIRE-DRUM.

(*Ardea Stellaris*, Lin.—*Le Butor*, Buff.)

THE Bittern is nearly as large as the common
Heron; its legs are ſtronger, body more plump
and fleſhy, and its neck is more thickly cloathed
with feathers. The beak is ſtrong at the baſe,
ſtraight, ſharp on the edges, and gradually tapers
to an acute point; the upper mandible is brown,
the under inclining to green; the mouth is wide,

25: A page from Francis Willughby's *Ornithologiae*, 1676. Folio. The
book was another of Bewick's sources for the compilation of the text of
the *British Birds*. (Natural History Society of Northumbria)

Among Bewick's many exchanges of correspondence with naturalists, one of the most interesting arose from his giving Captain Mitford lessons in etching and engraving. Mitford, who collaborated with Prideaux John Selby in the first life-size portrayal of British birds,[1] wrote to Bewick after his return from the workshop:

According to promise Mr Selby sends you an etching of the Scops and Little Owl. I also send you one of my own and we will be obliged by your remarks on them and should feel highly honourd if you should think them good enough to take a Copy of them for your British Birds. Mr S: has just slightly tinted them over to shew their Colour – they are as large as life. We are now nearly compleat with the Owls and have done several of the Hawks. As we begin *now* to understand the art of Stopping out better we are in great hopes of improving and I trust in time that with perseverance during the *bad* weather days to arrive at greater perfection. I cannot say what credit you may have in *me* as your pupil but *I* think I may justly claim a good deal for *mine*, as Mr Selby was not aware of the process of engraving untill I shew'd him on my return from *your School*. As we take impressions in plaster of parris[2] we will thank you to send us out a little good Ink as that which they use at Alnwick is very course –[3]

Bewick's candid opinion and his description of his own difficulties in engraving was given in the following reply:

I received your obliging letter of the 16th Inst accompanied with four Impressions of your & Mr Selby's Plates of the Buzzard & three Owls – I feel much pleased at your performances & altho' they carry about them every feature of the work of Gentlemen Artists or of Painters etchings, yet they are, in my opinion superiour as to drawing & effect to things of the kind done in a more finishd manner, in works on Ornithology of high repute – not having any of the specimens before me, from which you have taken your drawings, except the 'Scops' I speak to its accuracy more confidently than the rest, on which I have to trust only to my memory — I have not been able to ansr your letter sooner, having been confined to home with a severe giddiness in the head wch prevented me from either readg or writing any thing – The Doctors I think calld my complaint a 'determination of Blood to the head' – this may be so but I think I brought on the dizziness by too long and too close application at work. I was busied when this happen'd upon cutting on Wood the 'Scops', of a size not much bigger than the tail of your figure, & I nead not describe to you, even the attempt at imitating all the Barrs spots & freckles which are sprinkled over the whole plumage of this curious little Bird. We here with send you a Box of printing ink, perhaps sufficient in quantity, for your present purpose, & it is better to have it fresh –...[4].

Of the drawings for Bewick's own books, it is those for the *Birds* that have survived in the greatest numbers, and it is for the *Birds* that he first employed colour. Although he speaks in his *Memoir* of using colour as a

[1] *Illustrations of British Ornithology*, 2 vols, elephant folio, Edinburgh, 1821–32. The work contained 218 hand-coloured plates, of which 26 were by Mitford who was Selby's brother-in-law. [2] An unusual means of taking proofs which avoided the necessity of having the usual copper-plate rolling press. [3] TB from Captain (later Admiral) Robert Mitford, 16 October 1819 (Editor's Collection). [4] TB to Captain Robert Mitford, 27 October 1819, MS Draft (Editor's Collection).

child, it was obviously not considered a necessity when he first set out to produce preliminary studies for his wood engraving. As subjects, birds obviously presented a greater difficulty in the invention of a vocabulary for the monochrome engraving of their hues, tones and textures. When he went to Wycliffe, the many coloured engravings he came across in Tunstall's library, and the many brightly plumaged foreign species in the museum collection, could only have encouraged him to use his colour box.

Virtually all the surviving drawings of birds relate to the book's engravings, apart from some larger-scale studies such as the very fine Fieldfare (Vol.2, p.131) and the almost amateurish Snow Bunting.[1] Their relationship to the finished engravings varies and it is not possible to say that in every case the engraving is superior. In their overall design and strength, the drawings of the birds, being preliminaries, are often at a disadvantage, but there are many exceptions in the actual portraiture. For example, the extraordinary finish, subtlety of colouring and animation in the drawings of the Wren (Vol.2, p.53), Cuckoo (Vol.2, p.23) and Green Grosbeak (Vol.2, p.32), could not be matched by the graver; and the wintry landscape that makes such a fine background to the Titlark (Vol.2, p.44) is neglected completely in the engraving – though this is more likely to have been a simple matter of expediency. Usually the telling relevance of background detail is seen to be developed in the engravings, though here again exceptions can be found, as in the case of the Grey Lag Goose (Vol.2, p.105) where the skein of geese in the sky is lost in the engraving.

How long a time elapsed between the making of the original drawing and the completion of the engraving it is difficult to know. Occasional detail is available, for instance in the case of the Brent Goose (Vol.2, p.104) where the first study was drawn at Wycliffe in 1791, and the block engraved in July 1801 with additional reference to a freshly shot specimen. In some instances it will be seen that an intermediate pencil drawing was made for transfer to the block surface, in which the opportunity was taken to modify the bird's proportions or attitude from that first shown in the watercolour – the Water Rail (Vol.2, pp.82–3) and the Greater Spotted Woodpecker (Vol.2, pp.26–7) are typical examples – and sometimes to develop the basic background detail, as for the Yellow Bunting (Vol.2, pp.36–7) and the Willow Wren (Vol.2, pp.54–5). There are a number of pencil drawings which have been used for transfer which may never have had a related watercolour study, though it cannot be assumed that they were in less need of such preparation. Drawings of the kind reproduced in Vol.2, p.124 showing a study of the head and feet of the Common Tern, and the annotated sketches of the Mallard and the head of the Teal shown here [Figs.26 and 27] are regrettably very rare. It seems likely that many were discarded as being of no consequence, though for us they probably have as much interest as the most finished drawings.

As with the *Quadrupeds*, Bewick's greatest successes lay with the subjects he saw most frequently and close at hand – the garden birds for instance, such as the Robin, Coal Tit and Wren. He had great difficulty with

[1] Laing Gallery. Reproduced in D.C. Thomson, *The Water Colour Drawings of Thomas Bewick*, 1930, p.xxiii.

the correct representation of water, and many of his swimming water birds are extraordinarily clumsy. The Golden Eye (Vol.2, p.112) is a typical example, where we see his unresolved problem of trying to combine the information relating to the bird's feet and their use in the bird's natural environment. It is of course too easy to overlook the difficulties of the naturalist of Bewick's time who had none of the advantages of the

26: Bewick's annotated pencil study of the Mallard.
(Natural History Society of Northumbria)

telephoto camera lens and powerful binoculars. Telescopes there were, but his own had a limited power and a very limited angle of view.[1]

The foliage and landscape backgrounds to the land birds are in general masterly, although he seems to have had great difficulty with pine and fir trees, to which he seldom managed to give more than two dimensions. The engravings of the Cross Bill (Vol.2, p.30) and the Wood Grouse (Vol.2, p.64) show this particularly: their drawings give only the sketchiest hint of the trees. Occasionally the handling of the bird's

[1] Now in the possession of the Wildfowl Trust, Slimbridge, Gloucestershire.

perch is less than happy, and in such cases (see the Green Grosbeak Vol.2, p.32) the softness of the drawing has an advantage.

The beginning of Bewick's maturity in the handling of the vignette form appeared first in the *Quadrupeds*, particularly in the engravings of the dogs and foxes, but it was in the *Birds* where the backgrounds to so many

27: Bewick's annotated pencil study of the head of the Teal.
(Natural History Society of Northumbria)

of the subjects lent themselves so well to the treatment, that it was most fully developed. But a fully developed vignette is relatively rare amongst the drawings of the principal subjects.

For many of Bewick's admirers, his tail-pieces give as much if not more pleasure than his birds and animals, and here many more of the preparatory drawings are completely finished as vignettes. In the first edition of the *Quadrupeds* there are no more than twenty or thirty that can be placed with the best, and

although others were added in subsequent editions, it is in the *Birds* that we find the largest number of fine subjects.

The irregular outline of the vignette combined with the panel of text made for a particularly harmonious book page, and it is surprising to discover that Bewick apparently favoured a bordered engraving. His daughter Jane wrote of this: 'My father always approved of borders round wood cuts. When in London in 1828 he and Northcote had a discussion on the subject. They both agreed that Wood cuts with borders looked best.' [1]

In the introduction to the sixth edition of the *Birds* Bewick wrote:

When I first undertook my labours in Natural History, my strongest motive was to lead the minds of youth to the study of that delightful pursuit. . . . My writings were intended chiefly for youth; and the more readily to allure their pliable, though discursive, attention to the Great Truths of Creation, I illustrated them by figures delineated with all the fidelity and animation I was able to impart to mere woodcuts without colour; and as instruction is of little avail without constant cheerfulness and occasional amusement, I interspersed the more serious studies with *Tale*-pieces of gaiety and humour; yet even in these seldom without an endeavour to illustrate some truth, or point some moral. . . . [2]

Bewick's particular delight in the creation of his tail-pieces was as important to him as their serious purpose. In 1825 his naturalist friend John Dovaston wrote of this: 'He says he does not feel any deficiency of his imaginative powers in throwing off subjects of fancy for his *tale*-pieces; which are his favourite exercise. He does the Bird as a *Task*, but is relieved by working the scenery and background; and after each figure, he flies to cut an ornamental tail-piece with avidity, for in the inventive faculty his imagination revels. . .'.[3] Bewick himself wrote to Dovaston in the same year: '. . . I have nearly *fagged* through my task amounting to thirty-three new birds, and shall gladly apply myself again to my Tale-pieces, as I find it much less laborious "to throw off these fancies" than to *try* to put life into dead skins. . .'[4]. In an earlier letter he had said: '[I] am furnishing Vignettes as fast as I can, my *dear Jane* tells me I have finished above seventy – but to me this is an endless field. I cannot do these things half so fast as I can think of them. . . .'[5] Observations of this kind appear to be confined to Bewick's later years, but it is easy to understand the relaxation he found in creating the tail-pieces after the labour of engraving several hundred figures of birds and animals in which the disciplines of portraiture would have been severely taxing.

Bewick's contemporaries, and critics later in the century, were universal in their praise, and for many it

[1] Written in an extra-illustrated copy of the *Memoir*, in November 1868, next to some bordered engravings for an edition of *Robin Hood* (Editor's Collection). James Northcote's *Fables* had been published in 1828, the year of Bewick's final visit to London. Like those for Bewick's own *Fables*, the illustrations were bordered. [2] *History of British Birds*, Vol.1, 1826, pp.iii–vi. Written with the assistance of J.F.M. Dovaston, and disapproved of by the book's printer Edward Walker who contrived to omit it from many copies. [3] MS Tour Journal of J.F.M. Dovaston, 1825 (Editor's Collection). [4] TB to J.F.M. Dovaston, 26 November 1825 (British Library, Egerton MS 3147). [5] Ibid., 3 June 1824.

was the tail-pieces that formed the focus of their attention. Professor John Wilson (as 'Christopher North') wrote in *Blackwood's Magazine* of July 1825: 'Bewick's *excellence* is not of the mechanical sort . . . His fame does not rest upon this. It is his graphic tact – the truth of his conception and delineation of nature, that will carry him down to posterity. . . . Of Bewick's powers, the most extraordinary is the perfect and undeviating accuracy with which he seizes and transfers to paper the natural objects which it is his delight to draw. His landscapes are absolute facsimiles . . .'. C.R. Leslie's well-known appreciation spoke of Bewick as a 'truly original genius' and said of the tail-pieces: 'there is often in these little things a deep meaning that places Bewick's art on a level with styles which the world is apt to consider as greatly above it. The student of Landscape can never consult the works of Bewick without improvement'.[1] Further praise came direct to the family in a letter to Robert Bewick in which James Ward the painter had been reported as describing the tail-pieces as 'the *finest things* in art'.[2] As a portrayal of rural life in late Georgian England there is in fact nothing to compare with them; they reflect the mood and character of the Northumberland countryside with the greatest sensitivity. They do of course have a very great charm, a charm inherent in the miniature, which has sometimes been the cause of their being dismissed by sceptics as having little merit beyond a certain rustic whimsicality. But so many of the tail-pieces convey such intensity of feeling, so much affection and truth, with real originality and invention, that Bewick cannot be denied a prominent and unique place in English art.

Amongst the drawings some of the most attractive and exquisitely finished are the tail-pieces in watercolour, but with these it is difficult to see where their advantage lay. Such subjects presented fewer of the problems associated with the bird portraiture, and it is not possible to say that the most successful engravings depended on the highest degree of colour and finish. The restrained, harmonious palette and the delicate handling of the landscape distances are remarkable, but in many cases the subjects, although already strong in their sense of design, gain in force by translation to the engraved print. In the expression of the narrative content it can be seen that Bewick frequently added telling details to the engraving, such as, for instance, the well-fed peacock on the wall (Vol.2, p.154), the startled heron and the dog (Vol.2, p.156), the crucial date on the stone (Vol.2, p.146), the snowman's pipe and the motto (Vol.2, p.143), and the legend on the tombstone (Vol.2, p.147).

While we have noticed the practical value of the use of colour in the bird portraits, and questioned such practicality for the tail-pieces, there is no doubt that its use gave Bewick much pleasure – and in his remark quoted above, 'mere woodcuts without colour', he even appears to have regretted its absence in his books. We know that he took off light impressions of his engravings, sometimes in a warm brown ink, specially for subsequent colouring: sets of selected figures from the *Quadrupeds* were thus presented to his children on

[1] *Hand-Book for Young Painters*, 1855, pp.144–6. [2] Francis Hollingworth to Robert E. Bewick, 1 November 1818 (Editor's Collection).

28: The first opening of Bewick's hand-coloured set of selected impressions from the *History of Quadrupeds*, presented to his daughter Jane, 1 January 1800. 9 × 5in. (Natural History Society of Northumbria)

New Year's Day 1800.[1] Prints from the *Birds* later had the same treatment,[2] and copies of the celebrated large engraving of the 'Chillingham Bull' were coloured – though later returned to him as 'unsuitable for the London market'. How he would have reacted to the possibilities of colour reproduction or even colour-separated woodblocks we cannot guess, though it may be that without the discipline created by the limitations of black-and-white engraving his work would have lacked the element essential to its success.

[1] The copy given to Jane Bewick is now in the collection of the Natural History Society of Northumbria. [2] A number of these were given to J.F.M. Dovaston in 1825 (Editor's Collection). An edition of the *Birds* was coloured with exquisite skill by Bewick's friend Richard Wingate, the Newcastle taxidermist, who also coloured his later engravings as they were produced, working from the original specimens (Atkinson, p.144).

The last of Bewick's own books to be published was his *Fables of Aesop* which appeared in 1818, having been in production since 1811. The record in his *Memoir* tells us that convalescence after a severe illness in 1812 gave him enough distance from the daily round of his engraving shop to revive a long-considered plan:

I could not however help regretting that I had not published a Book, similar to 'Croxalls Esops Fables', as I had always intended to do – I was always extremely fond of that Book, & as it had afforded me much pleasure, I thought with better executed designs, it would impart the same kind of delight to others . . . – As soon as I was so far recovered as to be able to sit at the window at home, I immediately begun to draw designs upon the Wood, of the Fables & vignettes, and to me this was a most delightful task – In impatiently pushing forward to get to press with the publication, I availed myself of the help of my pupils, (my son, W^m Harvey & W^m Temple) who were also eager to do their utmost to forward me in the engraving business & in my struggles to get the Book ushered into the world – Notwith-standing the pleasurable business of bringing out this publica-tion, I felt it also an arduous undertaking – The execution of the fine work of the Cuts, during the day light, was very trying to the Eyes, & the compiling or writing the Book by candle light in my Evenings at home, together injured the Optic nerve. . . . I found in this Book more difficulties to conquer than I had experienced with either the Quadrupeds or the Birds.[1]

The title-page of the book declares very plainly that it has 'Designs on Wood by Thomas Bewick' and a letter he wrote to his friend Robert Pollard in January 1816 tells us equally clearly of his precise relationship with his apprentices in the engraving: '. . . during the day I am employd in designing & drawing the subjects on the Wood – & this is rather a laborious kind of work – I am obliged to finish the drawing with miniature like minutia, otherwise my Boys cou'd not cut them – This also requires my close superintendance & help and when the Cuts are done I then go over the Whole.'[2] In this are resolved the questions of earlier commentators who could not reconcile Bewick's statement in the passage from the *Memoir* relating to his eye-strain when working on the cuts, with his declared use of apprentice assistance.

In February 1818, in a letter to John Bailey, Bewick wrote of Harvey's connection with the book after he had left the workshop. The letter confirms his own continuing involvement as designer:

I hope to derive some assistance in the cutting [of] the Fables from a young man who left me last September. As he expressed a wish to continue to work at them for me, I gave him a number of designs with him to London, which I had, on his acc^t drawn on the wood with a finish and accuracy of fine miniature paintings, and flattered myself that I cou'd put a finishing hand to them when he returned them; but he has sent me none of them back, and I fear he only intends to make a *blaze* about the *Fables* being of his doing, *at my expense*, in London. These are my conjectures, for I have often been served so before. . .[3]

Bewick had been involved in the design and engraving of fable subjects from his earliest days as an apprentice. Apart from those commissioned by Thomas Saint, the Newcastle printer and publisher, there

[1]*Memoir*, pp.131–2. The Weekly Engraving Book for the period records the engraving of the first *Fables* blocks in May 1811 (Laing Gallery, R.37). [2]TB to Robert Pollard, 29 January 1816 (Laing Gallery). [3]TB to John Bailey, 5 February 1818 (Quoted in Julia Boyd, *Bewick Gleanings*, 1886, p.65; original not traced).

THE
FABLES OF ÆSOP,
And Others,

WITH DESIGNS ON WOOD,

BY

THOMAS BEWICK.

THE SECOND EDITION.

" The wisest of the Ancients delivered their Conceptions of the Deity, and their Lessons of Morality, in Fables and Parables."

NEWCASTLE:

PRINTED BY E. WALKER, FOR T. BEWICK AND SON.
SOLD BY THEM, LONGMAN AND CO. LONDON,
AND ALL BOOKSELLERS.

1823.

29: The title-page (reduced) and an opening from the second edition of the *Fables of Aesop and Others*, 1823.

ourselves, and free from vice, yet if those with whom we frequently converse, are engaged in a lewd, wicked course, it will be almost impossible for us to escape being drawn in with them. If we are truly wise, and would shun those rocks of pleasure upon which so many have split, we should forbid ourselves all manner of commerce and correspondence with those who are steering a course, which reason tells us is not only not for our advantage, but would end in our destruction. All the virtue we can boast of will not be sufficient to insure our safety, if we embark in bad company; for though our philosophy were such as would preserve us from being tainted and infected with their manners, yet their characters would twist and entwine themselves along with ours, in so intricate a fold, that the world would not take the trouble to unravel and separate them. Reputation is of a blending nature, like water; that which is derived from the clearest spring, if it chance to mix with a foul current, runs on undistinguished, in one muddy stream, and must ever partake of the colour and condition of its associate.

THE HUSBANDMAN AND HIS SONS.

A HUSBANDMAN, at the point of death, being desirous that his Sons should pursue the same innocent course of agriculture in which he himself had been engaged all his life, made use of this expedient. He called them to his bed-side, and said: All the patrimony I have to bequeath to you, my sons, is my farm and my vine-yard, of which I make you joint heirs; bnt I charge you not to let them go out of your own occupation, for if I have any treasure besides, it lies buried somewhere in the ground within a foot of the surface. This made the Sons conclude that he talked of money which he had hidden: so after their father's death, with unwearied diligence, they carefully dug up every inch, and though they found not the money they expected, the ground, by being well stirred and loosened, produced so plentiful a crop of all that was sown in it, as proved a real, and that no inconsiderable treasure.

30: Two 'Pen & Ink facsim' tail-pieces from the *Fables of Aesop and others*, 1818. A third can be seen in the opening reproduced opposite.

were others in later years which appeared in similar books produced by men such as Soulby of Penrith and Mozley of Gainsborough and York. Most were designed in the same oval shape, often with decorative spandrels. Some of the surviving drawings – those of the most detailed finish – are somewhat less wide in their proportions than those for Bewick's own book (Vol.2, pp.210, 211, 212; Vol.1, pp.172, 173, 178). These may possibly have been the work of his apprentice Robert Johnson, perhaps for some earlier edition of Aesop commissioned by another publisher, and may thus have been the source of the mistaken and often repeated assertion that the 1818 *Fables*, which began production fifteen years after his death, were all of Johnson's design.

The preliminary drawings directly related to Bewick's book vary considerably in their degree of finish. From the letter to Pollard already referred to, it might be assumed that no more than a very basic sketch was needed, such as those for 'The Cock and the Fox' (Vol.1, p.181) and 'The Travellers and the Bear' (Vol.1, p.180). But there are some that have an interest as finished subjects in their own right, and all these appear to be the work of apprentices. Very many of the drawings are derived from the Croxall originals, which in turn go back to Francis Barlow and earlier artists.[1] Although some are close enough to be virtual tracings, in general there is an improvement in design, and in the engravings there are some superbly realised rural scenes and landscapes too often ignored, even by Bewick's admirers. The tail-pieces for the book generally have less distinction than those for the *Birds*, and a new manner of engraving some of them is apparent: described in the workshop records as 'pen & ink facsim' they reproduce pen drawings of a much looser style, line for line [Fig.30]. There are only a handful of tail-pieces in watercolour that in any way reflect the quality of the best of those drawn for the *Birds* (see Vol.2, pp.213, 216 and 217).

Bewick was a keen angler and it is therefore not surprising that of all the subjects of natural history that his admirers were encouraging him to take up, a history of British fishes appealed most strongly. In 1824 he issued a prospectus announcing that the work, 'with figures engraved by T. Bewick & Son', would be put to press in 1826,[2] but unfortunately the combination of Bewick's old age and failing powers, the difficulty of procuring good specimens, and the gentle diffidence of his son Robert, was too much, and the publication was never achieved. Seventy-nine preparatory drawings for forty-five different species were in readiness, and sixteen subjects were engraved, some of them remarkably fine. More than seventy tail-pieces were engraved, and eventually they were used in two posthumous editions of the *Birds*[3] and in the first edition of the *Memoir* published by his daughter in 1862. Robert Bewick's drawings display much distinction and accuracy (see Vol.1, pp.191, 193, 195); his father's sketches for the tail-pieces are generally no more than quick notes,

[1] See Edward Hodnett, *Aesop in England* . . ., Charlottesville, 1979. [2] There are at least five versions known, each showing a different combination of figure and tail-piece. One of them omits Robert Bewick's name as a partner in the enterprise. 125 copies were printed (Laing Gallery, R.69). [3] 1832 and 1847.

A

HISTORY

OF

BRITISH FISHES.

THE FIGURES ENGRAVED ON WOOD,

BY T. BEWICK & SON.

This Work is intended to be put to Press in 1826,

AND TO BE

PRINTED ON IMPERIAL, ROYAL, AND DEMY PAPERS,

TO MATCH THE HISTORIES OF QUADRUPEDS, AND BRITISH BIRDS,
AND THE FABLES OF ÆSOP.

Subscriptions

RECEIVED BY T. BEWICK AND SON, AND BY
ALL BOOKSELLERS.

31: A prospectus
for the unpublished
History of British Fishes,
1824. $8\frac{3}{4} \times 5$in.

though a number of the finished engravings which he worked himself have much of the quality of the years of his prime. Had the work been completed there is no doubt that Bewick would have had somewhat less of a success: as subjects, birds and animals lent themselves so much better to being placed in attractive settings of rock, foliage and landscape.[1]

Much of the workshop engraving for other publishers was done from the designs of specialist book illustrators such as William Marshall Craig and John Thurston, who sometimes drew directly on the wood blocks, or from ideas and notes sent in by the author, such as those for the translation of Le Grand's *Fabliaux.*[2] John Thurston was born at Scarborough in 1774 and after being trained there in drawing, he went south to London to be apprenticed to James Heath the copper engraver. He later applied his talents as a draughtsman almost exclusively to the wood engraving trade. He was highly skilled and obviously admired by Bewick. Their correspondence, and other letters from the publishers involved, provide a valuable insight into the way Bewick was prepared to collaborate with another artist.

In 1806, Bewick had been commissioned to engrave Thurston's designs for an edition of *Pilgrim's Progress* to be published by Poole of Taunton, and in April of that year Thurston wrote to him:

I enclose you a design from Pilgrims progress for Mr Poole, which I will thank you to engrave in yr best manner – I should have waited 'til I had drawn another to send along with it, but Mr P informd me that you wanted one immediately – The next parcel I send you shall contn two designs, but I must first receive a supply of Blocks to draw them upon – these I will thank you to furnish me with immediately – choose them as free from stain, & let them be as beautifully polished as possible – When you have executed 2 or 3 of ye Cuts, be so good as to send me proofs of them pr post – that I may touch upon them. . .[3]

In September Bewick heard from Poole:

Agreeably to your advice I sent the proofs to Mr Thurston who has touched upon them – and I now send them all to you again, with the cuts &c &c and doubt not but *you* will do me justice in returning them as speedily as possible by *Mail* . . . I am sorry Mr Thurston designed Christiana passing the ruin on so bad a piece of wood – There are certainly some masterly Strokes in it, but, altogether, it is not so good as the others – The upper part of the Group of Angels is rather naked, and that of the Trumpeter not well designed – but I hope you will improve it a little – Some little objection has been made to the Testicles of Apolyon being so much in view, but this cannot now be altered – It is certainly descriptive of the creature – Pardon my remarks – The Following is a copy of Mr Thurston's Letter, in which are some hints to you 'I inclose you the proofs from

[1]See Alwyne Wheeler, 'Thomas Bewick's projected History of British Fishes', *Festschrift für Claus Nissen*, 1973, pp.651–86. [2]Translated and edited by Gregory Way, 2 vols, 1796 and 1800. The extensive collection of papers and original blocks relating to the production of this book are in the collections of Mr David Chambers and the Editor. [3]TB from John Thurston, 26 April 1806 (Editor's Collection).

P.P. with such Remarks as appear to be necessary – The *white* touching alone can be imitated by the Engraver, but the black touches alone may be of service to you in the printing, by pointing out the places where the principal force is required; On examining the prints more closely, I think there will be no occasion for overlays, only print them with fine *black and thick Ink* and the blacks will come up sufficiently – Please to observe to Mr Bewick that the white touching does not signify that the lines should be taken out, but only lightened as much as they will bare...'.[1]

Bewick had obviously overcome his original wish to work from drawings on paper rather than on wood,[2] perhaps because he had apprentices to whom he could delegate such work if he found it disagreeable. It is interesting to see that in the edition of Thomson's *The Seasons*, published by Wallis in 1805 – for which the designs were also supplied by Thurston – the figures retain everything of Thurston's manner, whereas the trees and foliage, although showing something of the apprentice Clennell's hand, could have come from no other stable but Bewick's.

Another interesting example of commissioned work for which there is detailed documentary background was a series of engravings of $1\frac{1}{4} \times 2\frac{1}{4}$ins for a children's book published by Henry Mozley of Gainsborough. Here Bewick was employed as a designer, and the text was to be written to suit his drawing:

For a New Reading made easy I am about to print I shall want the above Cutts [various animals and birds] – make them as entertaining as you can by putting any thing on the back grounds for instance to the Cut of the Horse put a Child going too near a Horse and getting kicked, and also any thing applicable to the back of each and then when we see what they are, a little entertaining story may be attached which shall make mention of the circumstance you put in. – I shall also want a Frontispiece $2\frac{1}{4}$ Inches by $3\frac{1}{2}$ – let this be a House (supposed to be a School) with 'School' over the door and children either playing – going to School or leaving School – I leave this entirely to you.

I will thank you to let me have these Cuts as soon as you can – I dont want them particularly fine – (being only for a Reading easy) but neat & serviceable . . . By way of Variety you may in some of these Cuts make them entertaining in the foreground instead of the Back – for instance you may make boys riding on the Ass – a Cat setting up her back at the dog &c &c for the more entertaining they are the better and however you do them – little stories can easily [be] adapted to them.[3]

For the jobbing engraving on both wood and metal that provided the bulk of the workshop's trade, there are a number of attractive studies. Some of these such as the bill-head for Hogg & Hind (Vol.2, p.227) and the book-plate for John Anderson (Vol.2, p.222) are by Robert Bewick, and show a delicacy of handling as fine as the vignette drawings for the *Birds*.

[1] TB from John Poole, 2 September 1806 (Editor's Collection). [2] TB from John Thurston, n.d., answered by TB 19 November 1802: 'You have expressed a wish that I should draw upon paper, rather than wood . . .' (Editor's Collection). [3] TB from Henry Mozley, 15 September 1802 (Editor's Collection). Mozley was clearly inspired by the anecdotal content of Bewick's tail-pieces for the *Quadrupeds* and *Birds*, and here quoted incident relating to some of them. No drawings appear to have survived and the book has not yet been identified.

The majority of the subjects reproduced in these two volumes were drawn for the engraving of a woodblock. An obvious feature in many of them are the crease or fold marks at their edges which show how the paper was fixed over the block during the process of transfer. For Bewick himself, all that was necessary was the transfer of the basic elements of the design and to do this he first blackened the back of the paper with a soft-leaded pencil, and then after placing the drawing on the block, he firmly scribed the outlines with a fine point. This scribing can be seen in many of the drawings if they are held at an angle to the light. The surface of the block was probably given a preliminary coat of 'whiting' chalk or brick dust: this would give it a 'tooth' that would more readily take a pencil mark when the silvery 'ghost' of the transfer lines were worked up. As the essence of Bewick's engraving style was his working from black to white, seeing every stroke he made as a white line out of black, it might be thought that he would blacken the surface with ink before transfering his drawing. There is in fact no evidence of this, but it would not have been essential, for pale though the boxwood is, a fresh cut in its surface still appears considerably lighter by contrast. Bewick's friend Dovaston described how he prepared the block surface for the pupils, in black and white, from which the white was cut out, and this no doubt would have been the nature of the minutely finished designs of the *Fables* already referred to.[1] Of Bewick's own method Dovaston wrote in 1825:

. . . he had early acquired so ready a facility himself, that simply with the graver on little, and often no, outline, he worked the design on the block at once. . . . He very seldom engraved from any other copy than nature, having the bird (always alive if possible), or other subject, before him, and sketching the outline on the block, filling up the foregrounds, landscapes, and light foliage of trees, at once with the tool, without being previously pencilled.[2]

A further hint of Bewick's working method comes in his letter to J.L. Philips of Manchester, written in March 1794, and referring to the possible loan of 'Abbat's drawings of American birds'[3]: '. . . it wou'd be of the greatest advantage to me; as I could then make a slight sketch, which I could immediately transfer to the wooden block & so finish it from the original drawing.'[4]

For engraving Bewick used the tools of the metal engraver, some of which were bought in from Sheffield,[5] though he very probably faced and pointed them to suit his own hand. The block to be worked was placed on the curved surface of a leather-covered rest made of cast lead. This convex surface provided the maximum of freedom for the rotation of the block: much of the variation in an engraved line's direction came from the turning of the block into the cutting tool.

Although it had been used before his time, Bewick's technique for lowering local areas of the engraving surface, to bring out the effects of softness in distances, and the texture of fur and feather, appears to have

[1] See p.49 above. [2] 'Some Account of the Life . . . of Thomas Bewick', in Loudon's *Magazine of Natural History*, November 1829, p.430. [3] John Abbot (1751–?1831). Until their sale at Christie's New York in 1980, these drawings were in Chetham's Library, Manchester. [4] Fitzwilliam Museum, Cambridge. [5] David Martin to Ralph Beilby, 18 November 1784 (Editor's Collection). A former apprentice, his letter includes a bill for various types of graver.

been something he discovered for himself in collaboration with his old friend William Bulmer who used to prove his engravings during their apprenticeship.[1] It was a device that with the soft spongy impression employed by the printers of his day, made effective printing possible – provided the paper had been properly conditioned by damping and inks of sufficient quality had been selected. He was not always so fortunate, despite his constant supervision of the production of his books. He certainly used an eye glass to magnify the work when he was older; and when he worked at home in the evenings, two double-wicked candles provided the light he needed.[2] We have no precise evidence from Bewick himself as to how long he took to engrave one of the larger bird subjects with full background,[3] nor do any of the drawings reveal signs of the pre-planning of his lowered areas, which had to be scraped down before engraving began.

Something should here be said of Bewick's methods of translating hue, tone and texture into monochrome engraving. That he was a white-line engraver, working from black to white, does not imply that he made no use of black lines in his work, but in general where these occurred they were not the result of laborious cutting round lines previously drawn, in the manner of the reproductive engraver; rather, they came from the direct and expressive cutting of whites, with a thin space of black left between them. He used very little cross-hatching either in black or white line, and he never fell to imitating the effects obtained in other media. Descriptive texture was important to him and he devised his own formula for every surface he had to depict. The masterly forms of his trees were made up with massed sprays of foliage, cut a leaf at a time, with more solid white in the lighter areas and with white outline in the mid-tones; in the very lightest areas the leaves appeared in black line – never slavishly cut, but always resulting from vigorous white cutting. The fur and feathers of animals and birds inspired textures dependent on their length, colour, and degree of coarseness. Coarse hair he cut to suggest direction as well as tone and length, using finer, more widely spaced lines in the darks, and in the lights coarser, and more numerous lines. For the smooth-coated creatures Bewick's engraving turned to the expression of their structure and form. Throughout most of his work Bewick used light and shade to express form and local colour rather than for naturalistic effect.

Many more specific references could be made, but enough has been remarked upon to set the enquiring eye onto a closer examination of Bewick's remarkable technical skill and invention. One of the most useful demonstrations of his excellence can be had from the comparison of one of his engravings with a copy by a leader of the immensely skilled school of reproductive engravers that succeeded him: the exquisite precision of the copyist loses all the harmony created by the vigorous, self-expressive line of the master [Fig.32].

The hard, close-grained boxwood used for engraving was seldom found in logs of more than six to nine

[1] This device was referred to by Papillon in his *Traite Historique et Pratique de la Gravure en Bois . . .* , Paris 1766. William Bulmer refers to this in his anonymous obituary of Bewick in the *Gentleman's Magazine*, February 1829, p.134. [2] Robinson, p.194. [3] Atkinson, p.147: 'In his younger days, he could finish one of his birds, if not accompanied by much foliage, in a day, or sometimes in a few hours; at a later period, though still possessed of excellent eyesight, he could not work so unremittingly, and they occupied a longer time.'

inches in diameter. It was bought from London merchants as 'Sticks of Turkey box'[1] and then prepared in the workshop, a local joiner being employed to slice it into rounds, across the grain, like a cucumber, to a thickness matching the height of printing type. The irregular shape of some of the pieces used, which often incorporated a section of the outside curve, can be seen in the crease marks of some of the drawings (see for instance Vol.2, p.99 the Red-breasted Merganser, and Vol.2, p.55 the Willow Wren). Dovaston observed

32: Bewick's tail-piece engraving of the starving sheep from the *Quadrupeds* (left) and a copy from Chatto and Jackson's *Treatise on Wood Engraving*, 1839.

Bewick's 'economy of boxwood; the pieces being circular, he divided them according to the size of his design, so as to loose little or none; and should there be a flaw, or decayed spot, he contrived to bring that into a part of the drawing that was to be left white and so cut out'.[2] Sometimes the size of the block forced the modification of the design – see for example the 'Dog and Pan' vignette (Vol.2, p.165) and the 'Boy and Nest' (Vol.2, p.164). The timber would have had to be kept for some months to season after being sawn; the surface would then have been prepared – probably with a plane followed by the cabinet maker's scraper.[3]

The lateral reversal of the printed versions of the designs, seen so clearly in this book, comes naturally from the direct transfer of a drawing to the engraving surface. In one of the drawings – the tail-piece of the 'Two Old Soldiers' – the effect of reversal has been anticipated and the two men have been drawn shaking

[1] His brother John acted as agent for its purchase when in London (TB from John Bewick, 19 February 1788, Collection Mrs John Hack). [2] Loudon's *Magazine of Natural History*, November 1829, p.430. [3] This method is still used by the last surviving English firm making blocks for wood engravers: T.N. Lawrence & Son, of Hatton Garden, London.

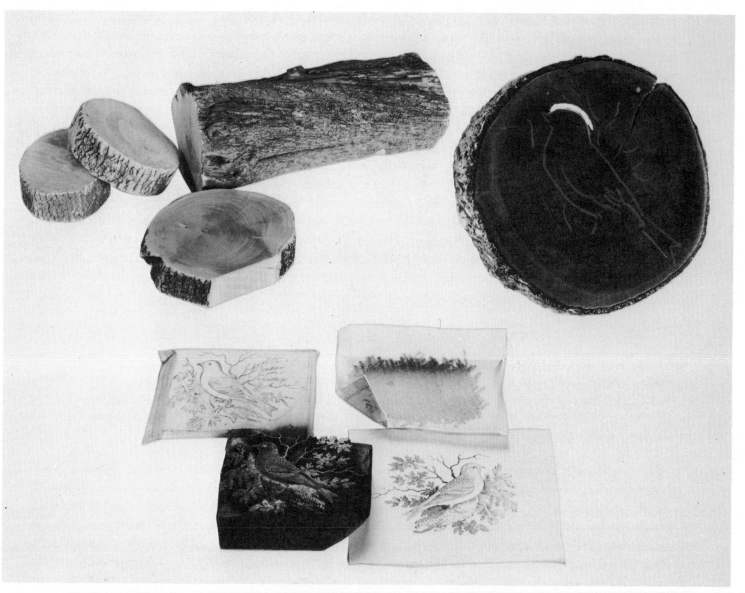

33: (*Top left*) A small log of boxwood, with three 'rounds' or slices, cut across the grain to a thickness equalling the height of printing type. (T.N. Lawrence & Son); (*top right*) An untrimmed round of boxwood on which can just be seen the silvery outline of the lead pencil transfer, and the clear white mark of a broad graver stroke clearing the bird's outline. (Editor's demonstration piece); (*below*) A folded drawing (in reproduction) and the same shown with the soft lead of a pencil rubbed across its underside for the process of transfer. Fine-pointed pressure is applied on the outline only. Shown together with Bewick's original block (the Lesser Redpole from the *British Birds* – blackened by printing ink) and a modern impression.

each other by the left hand (Vol.2, p.177). The tail-pieces of the 'Mower' (Vol.2, p.157) and the 'Beggar and Dog' (Vol.2, p.154) may also have been drawn thus so that the left-handedness of the principal subjects would revert to the accepted convention in the printed engraving. There are a number of exceptions, where both drawing and engraving have matching aspects. In the case of the vignettes, most appear to involve the maintenance of right-handedness in the figures – as, for example, the 'Town Sportsmen' (Vol.2, p.182) the 'Stonebreaker' (Vol.2, p.142) and the 'Sportsman and Shepherd' (Vol.2, p.159). To achieve this the drawing would have been placed face down on the block, possibly using another piece of leaded paper to act under the scribing pressure. The paper used for the drawings was thin enough for an emphasised outlined to be seen through it. It is less easy to see why there appeared to be a necessity to maintain the direction of some of the figures in the *Quadrupeds*, such as the Cur Fox (Vol.1, p.106) and the Mastiff (Vol.1, p.109).

Apart from the few that were inscribed and those known to have been done at Wycliffe in 1791, it is virtually impossible to give really accurate dates for the drawings. In the two principal collections, all of them have been securely mounted by their edges which prevents the discovery of possible watermarks or annotation. The blocks for Bewick's own books began to be itemised in the workshop records after 1797 when his partnership with Beilby ended, and so for the second volume of the *Birds* and for the *Fables* we are sometimes able to discover an engraving date, and sometimes, more rarely, the name of the engraver.

Throughout Bewick's working life there were at least two apprentices in the engraving shop, sometimes as many as five, all engaged at different times and therefore contributing varying experience to the business. Not all of them were involved in wood engraving, for much of the shop's activity was devoted to engraving on silver and to jobbing work such as bill-heads and cards engraved on copper. In his *Memoir* Bewick pondered on the usefulness of apprentices:

– I had formed a plan of working alone without any assistance from Apprentices, or of being interrupted by any one – and I am not certain at this day whether I would not have been happier in doing so than in the way I was led to pursue – I had often, in my lonely walks, debated this business over in my mind, but whether it would have been for the better or the worse, I can now only conjecture – I tried the one plan & not the other – perhaps each way might have had advantages & disadvantages – I would not have experienced the envy and ingratitude of some of my pupils, neither should I, on the contrary, have felt the pride & the pleasure I derived from so many of them having received medals or premiums from the society for the Encouragement of Arts – & also of their taking the lead, as Engravers on Wood in the Metropolis.

Notwithstanding this pride & this pleasure, I am inclined to think I should have had (ballancing the good against the bad) more pleasure in working alone for myself, than with such help, as apprentices afforded, for with some of them I had a deal of turmoil & trouble – and others who shewed capacity & Genious, & perhaps served out their time without an interchange of a

cross word between us, yet these, from coming under the guidance of people of an envious & malignant disposition perhaps in unison with their own, were, after every pains & every kindness had been shewn to them, when done, ready to strangle me –.[1]

Though he was a man capable of great generosity and kindness, Bewick was certainly quick to suspect an injury and long in the bearing of a grudge. There is little doubt that the more spirited of his apprentices had a far from easy time with him. The standard period of engagement was seven years, usually from the fourteenth birthday, and apart from John, Bewick's brother, who was released after five years, all the young men of any consequence served their full time. The terms varied, depending on the circumstances of the apprentices' parents or guardians; those for John Anderson ran as follows: 'That Dr Anderson shall pay to B & B [Beilby & Bewick] the sum of Sixty Guineas as an Apprentice Fee for the young man & shall find him with Board, lodgings &c, for the term of three years, at the expiration of which time B & B will pay him five shillings ℔ week for the remaining four years.'[2]

A particularly interesting letter Bewick wrote to the guardian of John Jackson, who was being proposed for an apprenticeship, provides further detail of how the terms were modified for a promising child of less well endowed parents:

– As Engravers require much time & application before they can be useful, the Terms in consequence are not so advantageous during their Apprenticship as in most other pursuits — When we receive no Apprentice fee, we generally have our Apprentices upon the following Terms – 'The first, second & third years' they are kept by their parents or friends, & the remaining four years we allow them five Shillings ℔ Week. – As the Parents of this deserving Lad are poor, and it is intended to raise a Subscription to put him to Business, We can only add that we will do all we can to serve him, as it has ever been a pleasant reflection to me to anticipate future excellence in the Man from the early efforts of ingenious youth.

If the sum of £60 is raised for him & paid to us, we will allow him the following wages from the date of his Indenture viz. five shillings ℔ Week for the first two years, six shillings ℔ Week for the third & fourth years seven shillings for the fifth – seven shillg & six pence for the sixth, and eight Shillings for the 7th & last year of his Apprenticeship . . .[3]

The apprentices of greatest interest to posterity are John Bewick, Robert Johnson, Charlton Nesbit, John Anderson, Luke Clennell, Henry Hole, Edward Willis, Robert Bewick, Henry White, Isaac Nicholson, William Harvey and William Temple (see Appendix 1). Those of significance as draughtsmen and artists are Johnson, Clennell, Robert Bewick and Harvey, of whom more will be said shortly.[4]

[1] *Memoir*, pp.77–8. [2] Loose slip in workshop papers (Laing Gallery). [3] TB to Mr Laws, Prudhoe Castle, 22 February 1819, MS Draft (Laing Gallery). [4] There are few of John Bewick's drawings on which to base any opinion apart from a number of early pastel drawings, and a set of finished watercolours for the vignettes engraved in *Poems by Goldsmith and Parnell*, 1795, all of which are now in the British Museum. The pastels are large and amateurish, and show little of the confidence of the engraver.

34: A group of tail-piece engravings, selected to display the variety of styles to be found:

a. Bewick's earlier hand, less assured in design and slightly more crudely cut.

b. Bewick in maturity, with the mastery of his patterning of light and shade fully developed.

c. and d. Bewick's later work, displaying a greater freedom and length of stroke.

e., f. and g. Luke Clennell: in the cut of the fisherman his sweeping broad-leaved foliage (lower left) is as good as a signature; likewise the patterning of the rocks and the rounded solidity of his figures.

h. Robert Bewick's stiffness of line and want of harmony in the design is very evident.

j. Henry Hole's uncertainty in the foliage and lack of light and shade, show how difficult he found the translation of Johnson's delicate drawing (Vol.2, p.153) into black-and-white.

There was no apprentice contribution to the engraving of the *Quadrupeds*, apart from a few ornamental tail-pieces, as we know from Bewick's vigorous rebuttal of a note on Johnson's life which had said that he had drawn the figures on the wood:

... I feel myself very much hurt at the falshoods, which through your information to M[r] Pinkerton, have made their appearance so publicly in the world – M[r] P gives you up as his authority for saying, that my late unfortunate Apprentice, poor Johnson – had been employ'd by me to trace the figures on the Wood for the History of Quadrupeds &c – however trivial (light) this may appear to you – it does not by any means appear so to me, & my friends – it is making me look ridiculous (or worse) in the eyes of them & the Public, & must continue to do so, untill they are informed of the truth. — I do not suspect that you are the Authors of the falshoods, of which I complain – but I do *strongly suspect that your informant* from the most malicious motives, has been prompted to deceive you....'[1]

The engraving for the *Birds* was a different matter, and here, apart from a certain amount of documentary evidence, the difference in style of many of the tail-pieces is very clear – as can be seen in the examples shown in Fig.34. It was a perfectly natural situation: Bewick had apprentices to train, he had a fund of ideas, and while he could not let the lads loose on the principal figures, the more competent could be put to work on the tail-pieces under his supervision. Because they were being trained by him, there was no reason why – given the traditional master/pupil relationship – the results should appear under any but the master's name. The same applied to any drawings that might have been worked up for the same purpose.

One of the most talented of Bewick's apprentices was Robert Johnson, 1770–96. He had no part in the wood engraving, his training being devoted to drawing and to etching and engraving on copper. His association with his master seems to have been, in its early stages, harmonious and of great and mutual benefit, but it later became bedevilled by misunderstanding and bitterness. On the subject of his talent, and his assistance as draughtsman and colourist, Bewick is unequivocal, though his daughter Jane (or her co-editor Robert Ward) saw fit to omit the following long account of Johnson in the first edition of Bewick's *Memoir*:

– Our next Apprentice was Robert Johnson who did not incline to do wood cutting & prefering copper plate engraving he was almost wholly employed in that way & in it attained to great excellence – and besides that, he became great as a draftsman & colourist – but as he was of so delicate a constitution, that he could not bear confinement, we for that reason, set him to work to make sketches & views, where he had both air & exercise — It may be necessary to give a more detailed history, than ordinary, of this Boy on account of the unceasing pains I bestowed upon his tuition and my reasons for doing so. His Mother had been long a Servant in fathers House, where she became a great favourite and like one of our own family. — When she married, this boy Robert was her first born; and when he was christned I was to have been his Godfather – this however did not happen ... – in the mean time my father & mother stood sponsors for the child. As the boy grew up, he

[1] TB to Morison's of Perth, 1 March 1800, MS Draft (Collection Mr Bewick Hack).

having been almost constantly told, he was to be my Apprentice – he looked up to me as a kind of deity – & having been, at every opportunity, kept closely employed in drawing, & '*making pictures*', which were regularly shewn to my father & mother & through them to my Self, he thus came very early into practice – – As soon as he attained somewhere about his 13th year, his friends began to act upon the plan so long intended of putting these intentions in force, and in this business my father & mother stood formost, as the warm friends of the boy, & begged I would always shew the same disposition towards him & to take him under my fostering care — He was about a year too young to be bound as an Apprentice, but I took him into my house 'till the proper time arrived, when he was bound to my partner & myself for seven years – He was mostly employed in drawing, & was also at intervals practising himself in the use of the graver & in etching on copper – but being very delicate in his health, we were carefull not to confine him too closely at any thing — … The methods I took to learn him his business was also of a peice with his mode of living – I did not keep him so long at work, as to tire him, with whatever job he might be put to do, but especially in drawing, but then, whatever I gave him to copy, was to be done *perfectly correct*, & he dreaded to shew me work that was not so, altho' I never scolded him, but only, if I was not pleased, I put the drawing away from me without saying a word – sometimes indeed I remember of saying O fie! & in this way of treatment he attained to great accuracy – The next thing I put him to was that of colouring, chiefly my own designs, and these occasioned me much time & labour, for I made it a point of drawing these with great accuracy, and with a very delicately pencilled outline – The practical knowledge I had attained in colouring, was imparted to him & he saved me a great deal, of what I considered a loss of my time in being taken up in this way – and besides he soon coloured them in a stile

superiour to my hasty productions of that kind – indeed, in this way he became super-excellent, & as I conceived he could hardly be equalled, in his water coloured drawings of views & landscapes, by any artist – for some time, I continued to sketch his figures, but at length he neaded none of my help, in this way – I remember of his once coming to me & begging I would drawn or sketch in a tree for him – no Robert said I, but I will direct you to a place, where you will see such a tree as you never saw painted by any artist, in your life, and that was a tree then growing in *Adonis's Grove* – he went & endeavoured to do justice to his pattern, & I do not know that any one could have made a better likeness – As soon as the time arrived, that he became entitled to have wages from us, this tempted his father & mother to leave the country & to reside in Newcastle & to have him to board with them – how he was managed, as to his diet with them I know not, but it soon appeared to have been a wrong treatment in this respect, for he soon lost his health, & was from that time, seldom out of the hands of the Doctor; and at one period, of his apprenticeship he was about a year absent from our employment, either in the country or in being nursed with watchful care at home – he however became quite well by the time he was freed from his servitude with us, & he then commenced painting & engraving on his own account. In the former Art he seemed to be much patronized, and had I believe, turned his attention to oil painting – The last of his efforts in this line, was done under the patronage of the Earl of Breadalbane,[1] by whom he was employed to copy some portraits & perhaps some other things at [Kenmore] where he took ill of a fever & died in the year 1796 & in the 26 of his Age – and was buried there — It always appeared to me, that he would have become great, as a painter, but a delicate constitution & want of stamina prevented this –.[2]

[1] MS reads (incorrectly) 'Earl of Buchan'.　[2] *Memoir*, pp.196–8.

In an earlier passage, when referring to the trouble he had with a number of his apprentices, Bewick wrote of the bitter circumstances surrounding the last period of Johnson's time with him:

It is painful to me to dwell on a subject of this kind, which indeed I might spin out to a great length with much additional matter, but it may be sufficient to observe that I have taken a Boy & behaved to him uniformly with the kindness of a Father or a Brother & have watched with every pains in my power to instruct him – been liberal to him in pecuniary matters – employed the best physician to attend him when he was unwell – let him want for nothing – paid him his wages besides, whether at work or not at work, & in this my partner contributed his share, – and along with myself used every endeavour in our power to advance him in the world, & when all this was done, he shewed not a particle of gratitude, but observed that any 'cartman would take care of his Horse', & then put himself under the guidance & directions of a Company or confederacy of ill disposed envious & malignant persons, who after having laboured to poison the ears of the public & of the Jury – to bring us to trial, for the pay for work done without the leave of his masters, while he was our apprentice! & the business was so managed that a verdict was given against us – I did not fail to attack this Jury individually & to send the confederates a message, that there was not a man among them who was not a coward & a scoundrel.[1]

When we consider how tiresomely enigmatic some of the statements are, and when we find others at variance with the workshop records, we have at the same time to remember that Bewick was writing some thirty years after Johnson's departure.

First there is the matter of the precise time Johnson was with his master. The workshop cash books show that he was first paid a weekly wage on 26 May 1787, and that he did not become an indentured apprentice until 23 August of the same year, at the age of seventeen – three years later than was usual, and yet, from what we must assume from the *Memoir*'s record, four years after his first coming into Bewick's household. He worked out the full term of seven years, leaving the workshop on 23 August 1794. Some of the absences from work are recorded in the cash books, but not the full year referred to by Bewick, which may well have occurred during the time before Johnson was indentured. In April 1792 we find: 'Robert for the time that he was ill £1.4s & for the week 5s.' which indicates a period of five weeks; and in May 1793: 'Rob^t Johnson 3 weeks (ill) 15s'. Two doctor's bills were paid on his behalf in 1792 and 1793.[2]

The law suit was a sorry affair. An account of it is given by Robert Robinson:

The Earl of Bute,[3] in passing through Newcastle, called at Mr. Bewick's, where he was shown a portfolio of drawings by Johnson, with which he was so much pleased that he purchased as many as amounted to £30.[4] This sum Messrs. Beilby & Bewick retained, on the ground that they were the work of an apprentice, and that the making of such drawings was a part of his business. Johnson's friends took a different view of the matter, which ended in litigation. At the trial the case for the

[1] *Memoir*, p.78. [2] Workshop Cash Book (Laing Gallery, R42). [3] The fourth Earl, 1744–1814, who succeeded his father in 1792. [4] A sum variously recorded by other writers.

defendants broke down, it being proved by Charlton Nesbit, another apprentice, that they had never received any instruction from their masters in the art of painting in water-colours, and that it formed no part of the teaching necessary for an engraver. The action was tried in the Sheriff's Court, Newcastle, April 29, 1795. The bill of costs against Beilby & Bewick amounted to £9.10s.11d.[1]

The business records[2] show that a payment of £16.5s.6d. was made by the Earl of Bute on 7 October 1793. This is half 31 guineas, and as no other reference to the Earl can be found in the books, the payment is almost certainly related to the drawings transaction. If it is, then it can be assumed that either the reports were incorrect or that the other half of the sum was put to the partners' personal use and not recorded. Legal expenses for their own and Johnson's lawyer amounted to 11 guineas and £11.5s.6d. and were settled in 1796. For the case to have rested on the fact that watercolour painting formed no part of the training necessary for an engraver and that no training was received seems hard on Bewick and could have been no more than a legal quibble – presumably founded on the fact that the indentures of his apprentices did not specifically mention the subject. It is interesting to find in the account books that Johnson was actually paid £5 for two unspecified drawings in January 1793, before the Earl of Bute's visit, and 21s. 'on Acct of landscapes' in March 1794. It must be supposed that these were done in what his masters fairly reckoned to be his spare time. The lawsuit obviously rankled with Bewick and his family for many years. His daughter Jane wrote of Johnson: 'This ungrateful Rascal died Mad. The old father belonged to Stanhope his mealy-mouthed wife was my Grandmothers servant at Cherry Burn'.[3]

The true facts surrounding Johnson's untimely death are horrifying. Having worked in Newcastle on his own account for nearly two years, he was commissioned by Morison's of Perth to go to Taymouth Castle, the seat of the Earl of Breadalbane, to make copies of George Jameson's portraits of celebrated scotsmen. They had in train John Pinkerton's *Scottish Gallery* for which models for engravings were needed, and this was eventually published by the engraver Harding in 1799. A letter from Morison to Pinkerton records the following account of Johnson's last days:

. . . we received a latter from Kenmore, from the man in whose house he lodged, desiring us to send for him, as he was quite delirious; and by express, the day following, we were informed of his death. Some weeks before this, Lord Breadalbane and family had left Taymouth House, and he had continued his business in a large parlour, *without fire*. Anxious to get through with his job, and the hours of daylight but few, he frequently sat six and seven hours on a stretch, and contracted a terrible cold: a fever was the consequence: no person to take a charge of him, he neglected himself: it flew to his brain, and, terrible to relate, he was bound with ropes, beat and treated like a *madman*. It is a subject too painful to be dwelt minutely on: fortunately, the day before his death, a Dr. M'Lagan passing through Kenmore visited him, ordered him to be unbound, applied

[1] Robinson, pp.251–2. [2] Workshop Cash Book (Laing Gallery, R42). [3] Jane Bewick's MS notes on her father's correspondents (Laing Gallery).

blisters, &c: the day following the delirium abated: he became calm, and died in peace and composure. As none of us could go from home, we sent an acquaintance to see him decently interred; and so entirely were we strangers to him, that we know not more about his relations than that they lived at Newcastle. Mr. Kirkwood of Edinburgh,[1] who recommended him to us, advised his friends of his death; and a young gentleman went up to Kenmore and investigated his little matters. . . .[2]

Johnson's attitude to the commission is most interestingly shown in a letter he wrote to Pinkerton while he was working at Taymouth:

I hope the drawings I take will give satisfaction; but, as I am a little curious, I hope you will have the goodness to favor me with a few particulars concerning the nature of the publication for which they are intended, and also the style of engraving adapted for them; as it would, in a great measure, obviate some little uneasiness I have on that head, and regulate my manner of doing them in conformity to your purpose. In my opinion, they should be engraved (at least some of them) as much as possible in the manner of Houbraken's heads; as that sketchy, soft, close-stroked kind of engraving is the most beautiful and suitable representative of drawings, or old sunk-in indeterminate pictures, which a naked harsh outline, though sought with the most difficult accuracy, can but faintly express. Mr. Morison informed me that he understands they are to be engraved by first-rate artists in London: if this is the case, I would like to take the utmost pains with them, whatever may be my reward, and would wish to know whether the name of the delineator is put to the prints; being conscious of the very minute attention I pay to the resemblance of the originals. I hazard it to your judgment in excusing such boldness; and what I mean to say is, that except the engravings are done with judicious exactness from these drawings, I beg you will not put my name to them; as I think it a laudable precaution which every young artist should take and abide by, who has only his hands and his *little name* to depend on. From the price I have undertaken to do these at, and the *loose open sketching* mentioned in yours, a thought struck me, that a less laborious kind of drawing, with sufficient accuracy, (which I flatter myself able to do,) might answer your purpose as well, or, perhaps, better. . . .[3]

The confidence of the letter shows that Johnson's training had been most thorough and had provided a solid base for his talent. The exquisite quality of his drawings is several times referred to in Pinkerton's book, and they were for the most part finely engraved in stipple by Harding, the book's London publisher. Johnson's own skill as an engraver on copper seems to have been of no more than general competence, though a fascinating illustrated letter he wrote to his friend Abraham Hunter – also a former apprentice to Bewick – relating to their joint work on a view of Sunderland bridge, shows him to have been a master of the copper engraver's various stylistic conventions.[4]

[1] Robert Kirkwood was one of the principal copper-plate printers in Edinburgh and a correspondent of Bewick's. [2] Dawson Turner (ed.), *The Literary Correspondence of John Pinkerton Esq.*, 1830, i. 423–5; the letter dated 18 November 1796. [3] Ibid., pp.420–2. [4] Robert Johnson to Abraham Hunter, 4 August 1796 (British Library, Hodgson Papers Add. MS 50247). Written from North Queensferry on the Firth of Forth, on his way to Taymouth.

Reference has already been made to Bewick's vigorous denial of statements giving Johnson credit for work on the *Quadrupeds*. With the *British Birds* the situation was very different: in 1839 a detailed statement was published which gave the most specific references to tail-piece engravings worked from drawings by Johnson. It is sad that Bewick's own references to Johnson are not at all specific in the identification of his work; neither his diffident and retiring son Robert, nor his more vigorous daughters – jealous guardians of their father's reputation – ever found themselves able to confirm or deny the information. The list appeared in Chatto and Jackson's *Treatise on Wood Engraving* together with a long and generally appreciative survey of Bewick's work, which is full of interesting detail, but which was written without knowledge of Bewick's own account of his relationship with Johnson, and without direct access to the original drawings. There are a number of errors and misinterpretation of the facts. The purpose was to give credit where credit was due, but it was frequently taken as an act of spite and given little or grudging credence by subsequent writers.[1] John Jackson, who was promoter and part-author of the book, had been a not particularly popular apprentice with Bewick, between 1819 and 1823, having come to the workshop to finish his training after the failure of his first employers, Armstrong and Walker of Newcastle, and it was probably his unpopularity with the family that prevented an approach to them for information.[2] William Chatto was a Newcastle man, who like Jackson had moved to London where he worked in the wine trade and used his spare time to write topographical essays under the pen-name of 'Stephen Oliver'. Neither of the men had known Johnson and for the most part they relied on Edward Willis (apprenticed to Bewick 1798–1805) and William Harvey (apprenticed 1810–17) for their information. Ebenezer Landells who had been apprenticed to Isaac Nicholson – a pupil of Bewick's between 1804 and 1811, and Charlton Nesbit (apprenticed 1790–97) also contributed some detail. Nesbit was Johnson's only contemporary, and of all four men quite the best placed to provide information of value, but curiously little was forthcoming.[3] All of the contributors were relying on memories of their youth, thirty and more years before, which made for uncertainty in the attribution list.[4]

The tendency in most of the reactions to Chatto's account has been either to dismiss it, or to give it passing acknowledgment, without any attempt to examine either the drawings or the engravings closely.[5] Latterly,

[1]In November 1862, the Revd W. Kingsley wrote to Jane Bewick, quoting from Chatto & Jackson and offering 'to make the truth known'. She refused, saying that as she had hitherto 'declined to enter into any controversies' she would not do so now – 'more particularly as regards unscrupulous and unprincipled persons. I have "suffered enough and to spare" and now feel my Father's fame unassailable'. There is also evidence that Chatto had been in touch with Robert Bewick soon after the publication of the *Treatise* (Editor's Collection). [2]TB to Mr Laws, Jackson's guardian, n.d., MS draft of 1819 (Editor's Collection). A bitter complaint to the effect that Jackson had picked Bewick's brains of skills he had taken many years to acquire, and that now, while still on trial, was threatening to move to London without returning any benefit to the business. [3]Nesbit may not have been easily available to the authors. Willis's initials are shown against most of the attributions in the original manuscript. A note from Jackson to Chatto, written on 19 January 1836, reads: 'Willis is here, will you come over and keep him talking about Bewick &c while I write a mem. of it?' (London Library). [4]Of one tail-piece vignette a note reads: 'Harvey says "cut by Isaac Nicholson," Jackson says "by Harvey," Landells says "by Bewick himself"' (London Library, f.25). [5]A typical example is to be found in Joseph Crawhall's manuscript account of the lives of Johnson and Clennell, put together in 1867, and for the most part based on the printed sources. The original material he contributed is unfortunately meagre, though he does list a number of Johnson's larger drawings in his own and other collections. (Manuscript now in the collection of McGill University, Montreal.)

one of the greatest hindrances to a proper inspection of the drawings has been their multiple grouping on fixed mounts in the two main collections. But as soon as colour proofs of the reproductions for this book became available and it was possible to make more direct comparisons, certain distinct groups of style became apparent and something of this is shown here [Fig.37]. There is in fact no reason to cast doubt on Chatto and Jackson's main purpose. What has to be qualified is their assumption that all the listed 'Johnson' subjects, besides being of his final execution, were of Johnson's invention and design.

The principal figures in his natural histories were Bewick's main concern, and he answered his earliest biographer, Atkinson, quite specifically on the matter of their engraving, saying no more than six of them in the *Birds* had been handled by apprentices,[1] but of the tail-pieces – particularly the design of those to which Johnson's hand has been most closely identified in Chatto's list – nothing was said. It is quite plain to a careful eye that the landscape backgrounds to the drawings of the birds, which are without doubt by Bewick, show a very much looser handling than is seen anywhere in the precise and delicately treated tail-pieces – most of which Chatto attributes to Johnson. There are some preliminary pencil essays for these subjects which are clearly Bewick's and show his roundly formed leaves and more rugged trees, elements not apparent in any of the few signed works of Johnson that have survived, such as the view of Newbiggin (Vol.2, p.138). An interesting example is found in the 'Beggar and Mastiff' tail-piece (Vol.2, p.172): the pencil sketch, apart from its characteristic Bewick foliage, has a much less dramatic perspective in the drawing of the background building. According to one record, Bewick told John Hancock that Johnson could not draw out of perspective, so true was his eye[2]; emphasised perspective seems to have been a marked feature in much of his work. Among thirteen other examples of Bewick's preliminaries for drawings shown in this book, the 'Suicide' (Vol.2, p.149) and the 'Man crossing a Stream' (Vol.2, p.171) are typical. It is probable that many sketches by Bewick were destroyed after they had provided the foundation for Johnson's work. As Bewick was able to produce such fine engravings as the 'Stag drinking at a Spring' (Vol.1, p.133) and the 'Countryman' (Vol.1, p.157) from pencil beginnings, it may be that Johnson's finished watercolours had been given to him simply for practical exercise. How many of the birds were of Johnson's colouring it is very difficult to say. Although Bewick refers to his giving such exercise to his pupil, he is (for us) annoyingly unspecific. But there are enough dated examples of birds, either drawn at Wycliffe or after Johnson's death, for it to be seen that the pupil did not surpass the master in the delicacy of his handling of watercolour. To sum up on the question of the tail-piece attributions, it seems reasonable to accept that given Bewick's open acknowledgment of Johnson's skill, the survival of a fair quantity of Bewick's pencil preliminaries for the same subjects, and his position as instructor and inventor, he would have seen no cause to give Johnson a title-page acknowledgment.

[1] Atkinson, p.145. Three species were named. Chatto & Jackson list fourteen apprentice-cut birds – by Hole, Temple and Clennell, to which list Jane Bewick unreasonably referred as 'false altogether' (annotation of a letter to her from Revd W. Kingsley, 1 November 1862, Editor's Collection). [2] Crawhall MS (McGill University, Montreal).

35: 'The Milkmaid'. Watercolour by Robert Johnson,
c.1790. Signed. (Laing Gallery)

36: 'Treatment for Gout'. Wash drawing by Robert Johnson, c.1790.
Signed. (Laing Gallery)

a

b

c d

37: A group of tail-piece drawings selected to display the variety of styles to be found catalogued under Bewick's name.
Vol.2 page numbers refer to reproductions in colour.
a., b. and c. Bewick. (See Vol.2, pp.174 and 193)
d., e. and f. Robert Johnson (See Vol.2, pp.143, 145 and 153)
g. and h. Attributed to Johnson by Chatto, but likely to be by Clennell. (See Vol.2, p.195)
j. Robert Bewick. (See Vol.2, p.222)
k. Unidentified apprentice. (See Vol.2, p.230)

e

f

g

h

j

k

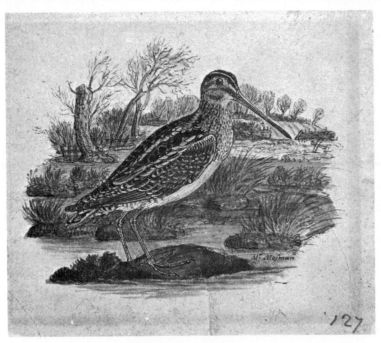

a

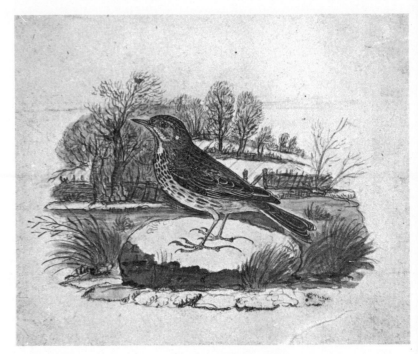

b

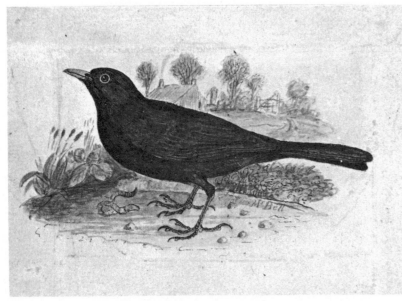

c

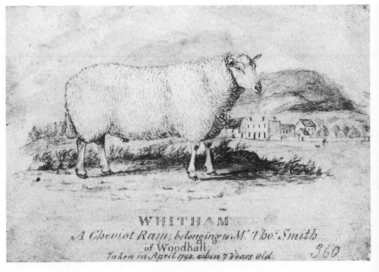

WHITHAM
A Cheviot Ram, belonging to Mr. Thos. Smith
of Woodhall
Taken in April 1790, when 7 Years old.

d

e

f

g h

38: Eight drawings grouped to show the difference in handling of the landscapes in Bewick's bird and animal drawings and
in the tail-pieces drawn or finished by Johnson. Vol.2 page numbers refer to reproductions in colour.
a., b., c. and d. Bewick. (See Vol.2, pp.18, 44, 75, 225)
e. Bewick's wash drawing of the reindeer for Consett's *Tour through Sweden* . . . , 1789. $5\frac{3}{4} \times 8\frac{1}{8}$ in. (British Museum)
f., g. and h. Robert Johnson. (See Vol.2, pp.143, 185, 189)

39: 'St Nicholas' Church, Newcastle upon Tyne'. Watercolour by Robert Johnson, *c.*1792. 12¾ × 16¾in. (Laing Gallery.) The figures of the two urchins jumping onto the rear axle of the coach, are so much more animated and truly drawn than any others, that they, and the idea itself, seem to be from another hand – possibly Bewick's. See the figures in the tail-piece, Vol.2, p.165, and Bewick's remark about drawing Johnson's figures for him, p.65 above.

The mistaken claim made by several writers, and by Chatto and Jackson in particular, that Johnson had prepared all the drawings for Bewick's *Fables of Aesop* has already been mentioned. It is particularly sad that Johnson's work unconnected with the Bewick books is now so rare. The view of Newbiggin already mentioned has a similarity of palette and contains a number of elements typical of the tail-piece drawings. It is plainly the work of a hand trained to draw on a small scale, and the finish of its detail appears more important than the strength and harmony of its composition. There are no independent drawings of the size and manner of the *Birds* tail-pieces, apart from the portrait of the Revd Christopher Gregson [Fig.40] in which there are some typical characteristics in the spindly trees and the long-bodied figure. The drawing of 'Bamborough Castle' [Fig.41] has rather more breadth and freedom than usual, and suggests that had he lived longer, Johnson might well have developed in this direction, as did Luke Clennell, when away from the influence of his master.

40: 'Ovingham Churchyard'. Watercolour by Robert Johnson, *c*.1790. (Pease Collection.) The principal figure is thought to be Bewick's mentor the Revd Christopher Gregson. Johnson's initials 'R I' can be seen at the bottom left. His trees are echoed in a number of the tail-piece drawings for the *British Birds*.

41: 'N.W. View of Bamborough Castle North^d'. Wash drawing by Robert Johnson, 1796. Signed and dated. 9¼ × 15¼ in. (Laing Gallery)

Of all the apprentices it was Clennell who developed most fully as an artist. His time with Bewick, between 1797 and 1804, is only briefly though proudly mentioned in the *Memoir:* 'Another of my pupils of distinguished ability, both as a draftsman and Wood Engraver, was Luke Clennell whose melancholly history, will be well remembered by the Artists if London & else where, and the simpathetic feelings, which was drawn forth & shewn to him by a generous public, by their subscriptions to a Print of the battle of Waterloo, from his painting of the decisive charge of the Guards, on that eventful day –'.[1]

Clennell was born the son of a farmer at Ulgham, near Morpeth, in 1781. Like his master, he is said to have shown from an early age an affinity for sketching and caricature. After his schooling, he worked with his uncle, a Morpeth grocer and tanner, but his passion for drawing continued unabated, until eventually he was

[1] *Memoir*, p.200

42: a. A vignette for a book-plate. Watercolour by Luke Clennell. $3\frac{1}{4} \times 5\frac{3}{4}$in. (Laing Gallery)
b. A vignette for the trade card of A. Cunningham, South Bridge, Edinburgh. Watercolour by Luke Clennell. $3\frac{1}{4} \times 5\frac{1}{2}$in. (Laing Gallery). These two vignettes show a much more vigorous use of deep tones than is usual in Robert Johnson's work. This together with his handling of foliage, casts doubt on a few of Chatto's attributions: see for example Vol.2, pp.195, 196 and 176.

43: 'A Sailor Ashore'. Watercolour vignette by Luke Clennell. $4\frac{3}{4} \times 7\frac{1}{4}$in. (Laing Gallery)

44: 'Bywell Castle on the Tyne'. Watercolour by Luke Clennell. $8\frac{1}{4} \times 11\frac{1}{2}$in. (Laing Gallery.) Engraved by J. Greig for Walter Scott's *Border Antiquities of England and Wales*, 1814, Vol.2, p.115. An example of Clennell's later and broader manner.

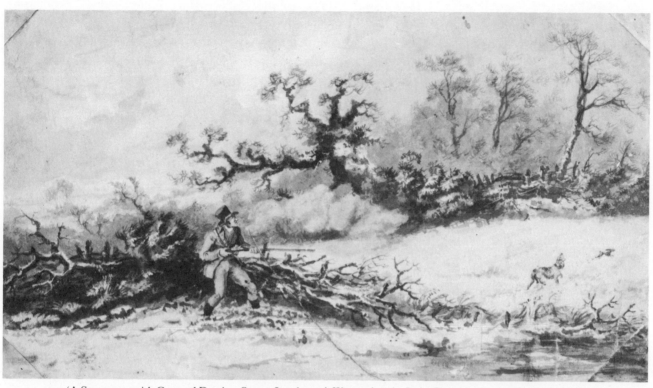

45: 'A Sportsman with Gun and Dog in a Snowy Landscape'. Watercolour by Luke Clennell. $5\frac{7}{8} \times 10\frac{1}{2}$ in. (Laing Gallery.)
Together with Clennell's vignette engraving (see the sweeping foreground foliage) of the same subject for the *British Birds*,
Vol.2, 1804, p.82.

placed with Bewick for the usual seven-year apprenticeship, in April 1797 at the age of sixteen. He was a ready pupil and his contribution to the second volume of the *British Birds*, which was in production throughout his time in the shop, was considerable: he engraved three of the figures, and at least forty of the tail-pieces. His engraving manner is distinctive and confident, with more sense of movement than Bewick's, as can be seen in the examples reproduced on p.62–3. His signed engravings for *The Hive*, published in 1806, provide many of the clues that identify his hand. After he left the workshop his manner became yet more free, particularly in some of his work for book illustration. The same can be said of his watercolour drawings: those of his maturity are remarkably fine and begin to show a breadth reminiscent of Girtin – those that he produced for Scott's *Border Antiquities*, engraved by J.Greig in 1814, provide some of the best examples. [Fig.44]. His rustic figures always display a sturdy muscularity, perhaps because he was himself 'small, and in-kneed'.[1]

It seems unlikely that Clennell would not have had a hand in some of the tail-piece drawings now catalogued under Bewick's name. Examples such as the 'Wonderful Fish' (Vol.1, p.168) and the 'Churchyard Cavalry' (Vol.1, p.170) have the vigour and contrast found in a few small drawings known to be his work [Figs.43–46]. His end was no less tragic than Johnson's, for in 1817 he became insane while working on a large painting that was to commemorate the dinner given to the allied sovereigns at the Guildhall in London. He lived, in varying stages of mental distress, until 1840. His wife, the daughter of the copper and steel engraver Charles Warren, and his son, suffered the same affliction.

William Harvey, who came to the workshop on trial in November 1809 at the age of 13, completed his apprenticeship in September 1817, and then moved immediately to London, first to study in the studio of B.R. Haydon. He soon became one of the leading wood engravers of his day. His competence as a draughtsman and designer brought him much work and by 1824 he had given up engraving to concentrate on drawing designs on the wood for other engravers. *The Tower Menagerie*, 1829, *Northcote's Fables*, 1828 and 1833, *The Gardens and Menagerie of the Zoological Society*, 1829, and Lane's edition of the *Arabian Nights*, 1839–41, are some of the innumerable books in which his work is found. There is a certain dainty unreality in his manner, particularly in his drawing of animals, which seldom seem to have their feet firmly planted on the ground. His contribution to the engraving of the *Fables of Aesop* Bewick acknowledged, and despite the evidence of Bewick's letter to John Bailey, there is no doubt that some of the drawings for the book were of his making – see for example the second version of 'The Old Lion' (Vol.1, p.176) and the head-piece to the Introduction (Vol.2, pp.214–15). Harvey was immensely industrious and was much liked and respected in the trade. His long life ended in 1866.

[1] Manuscript note on Clennell's life in an album of his drawings for the illustration of *Smollet's Works*, collected by James Storer, the engraver (V & A, Department of Prints and Drawings, 93 c.1).

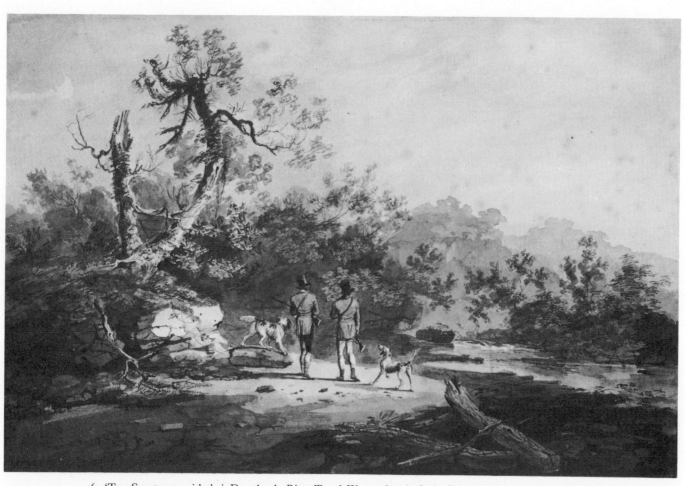

46: 'Two Sportsmen with their Dogs by the River Tyne'. Watercolour by Luke Clennell. $8\frac{5}{8} \times 13$in. (Laing Gallery)

Bewick's son Robert, who was born in 1788 and died in 1849, had a good deal of his father's talent, though not his genius, invention and originality. He was not helped by the indifferent health he suffered throughout his life, and it seems that he was either consumptive or asthmatic. This combined with the effect of his father's dominating personality, probably kept him from achieving a reputation of his own. He had besides, the increasing responsibility of running the general engraving business as his father's involvement gradually diminished after the illness of 1812. His apprenticeship ran between 1804 and 1810, and he was made a partner in the business on 1 January 1812.[1] As a wood engraver he showed no more than competence, but some of his etching and engraving on copper, and his careful delicate draughtsmanship deserves wider notice. In their detail a number of his drawings reflect the idiom of the etcher's needle, and the time he spent in the study of perspective is also to be found in his drawings of buildings and interiors. The interest in perspective irritated his father:

what can my Robert mean by poring constantly over & stupyfiing himself with Perspective – it has long given me pain to see him wasting his time in this way – how much better would it be for him & how much more agreable to me if he wou'd leave it off & take to drawing – he ought never to have the pencil out of his hand & ought to be almost continually sketching or making finished drawings — to be well conversant or practised in this is the requisite qualifications which is to enable him to glide pleasantly with his business thro' life & to make engraving the greatest pleasure to him, & without being Master of the pencil his business will become dull or perhaps irksome – he did once draw most beautifully & will easily do it again if he pleases – how gladly would I like to see this![2]

As late as 1825, Bewick was conducting a transaction for his diffident son:

I understood it was your wish, that my son should engrave for you, on copper, the Birds which I had done on wood, from the specimens in the Wycliffe museum & that he had a wish that I would draw for him the outline of the figure, of the hybrid Wood Grouse from Russia lately presented to our museum, by Mr. Hodgson, then, being sorry to deny him, on his first entering upon business on his [own] acc[t] & knowing how diffident he was about attempting to give the appearance of life to a stuffed specimen, I was willing to aid him in this instance as far as I cou'd – other matters concerning your publication,[3] in which I should have satisfied myself, crossed my mind & which I ought to have had settled when you were here – I wished to know the size of your page – the number of figures you might wish to have on each plate – the whole number of the birds you wanted engraved & the manner in which you wished the fig[s] to be done, to be ready at the time your work was intend[d] to be published – a great number if executed by slight etchings might probably as to time be done to meet your wishes – but if you wished the plates to be highly & accurately executed – it is likely you may not be aware of the time that would necessarily be taken up in

[1] Advertisement in *Newcastle Courant*, 1 January 1812. [2] TB to Jane Bewick, 28 June 1814 (Natural History Society of Northumbria). [3] G.T. Fox, *Synopsis of the Newcastle Museum, late the Allan, formerly the Tunstall, or Wycliffe Museum*, Newcastle, 1827. Robert Bewick etched the figure of the 'Rakkelhan Grous' and the Wombat.

finishing them so – I think, for instance, the Wood Grouse, with all its curious freckles, might take a month, to do it justice, others might indeed take up less time – but were the patterns, taken from the Wycliffe specimens, already finished, to be begun upon, the difficulty of the drawing & the engraving, is removed or nearly done away — should you think proper to employ him, as I first named to you & in unison with what I here state he will do his best to please you, but this he cannot hope to do if you hurry him for time . . .

The letter continued with the refusal of work for himself. He had less than three years to live and he found the preparation of the final edition of the *British Birds* as much as he could do:

M^r Thornhill called upon me last night with some cases of *ragged specimens* of Wycliffe Birds, by which I found you wished I could copy for your work, but this I cannot on any acc^t ever think of doing – with me that time is done away & the business before me precludes me from ever thinking of undertaking any thing else – Indeed I now consider myself like a Tenant whose lease is out, & is now become a *Tenant at will*. . . .[1]

Bewick finally had to reconcile himself to the fact that his son would never come to an equal reputation, but he was able to take a well founded pride in Robert's work on the *Fishes:*

The History of Fishes goes on slowly. I am now not so well able, as I used to be, to run about seeking Specimens, and am obliged to trust to the exertions of my son, who, from the accuracy & beauty of his drawings cannot be surpassed. . . .[2]

Robert's wasting of time with the study of perspective was forgotten.

After his father's death, Robert's diffidence continued. In a brief but delightful account of his meeting with him, William Bell Scott wrote:

One stormy, snowy evening, when, in the midst of my many unceremonious pupils, I felt very much as one may suppose a naked foot to feel in a hornet's nest, Albany Hancock's handsome face appeared advancing up the gallery, followed by a heavy, slouching, able-bodied countryman, as I thought, about fifty-five or so, with an absent, bewildered expression of face, the snow still lying white on his penthouse eyebrows. This was Robert, the son of Thomas Bewick, who had some of his father's talent in the technique of the craft, but none in invention or design. To this man I felt drawn in a singular degree, mainly by the almost reverent simplicity and diffidence of his manner, which evidently prevented him adequately and freely expressing himself. I had been told he was busy drawing and engraving figures of fishes from nature, with the intention of completing another division of natural history that might in some measure, though in a limited way, go with his father's celebrated volumes. I spoke of this – Hancock, I knew, being one of the encouragers of the scheme. He looked at me, then all about the gallery, as if in the presence of some perplexing enigma the solution of which was to be found somewhere about, and then answered, 'That's what I would like; but I don't know – maybe I canna; but I should like it if I durst.' This

[1] TB to G.T. Fox, Westoe, 31 December 1825 (London Library). [2] Bewick to Frederick Manning, 1 May 1827 (Collection Mr Francis Minns).

was so candid, and so touching in its modesty, I could not help contrasting it with the pretension current and necessary in the circles I had left in London. However, I found afterwards a very unpleasant cause assigned for this diffidence. His father was not satisfied with Robert's powers – old Thomas being an autocrat, and a little exacting in his requirements from his son as well as from his pupils. I found also his father had projected the book on fishes.

Between the rough honesty and simple manners of Robert Bewick and his father's genius I found a close relationship. There was a comfortable health about him, and the snow unmelted for a few minutes on his eyebrows and clothes reminded one of the enjoyment the paternal sketcher had in depicting mid-winter with its frozen covering of white. Robert was one of the last remaining adepts on the small Northumber-land bagpipes, and we were shortly after invited to take tea at a friend's house for the purpose of hearing him. He appeared, carrying the union-pipes under his arm, accompanied by two tall old-fashioned maiden sisters; but when the time arrived for his performance, he seemed as scared as some men are who have to make a public speech, and was evidently inclined to run away. Our host, however, who knew him well, proposed that he should tune his instrument on the landing outside the drawing-room door, which was a formula he appeared to understand; and after the tuning he played there, and we heard him perfectly, and applauded him much. The ice thus broken, he soon gained confidence, re-entered the room, and walked about excitedly playing Scotch airs with variations in the loveliest manner on that most delicate of native instruments.[1]

What opportunities there were for Bewick and his apprentices to see the original work of other artists it is difficult to discover. Public exhibitions were slow to spread to the provinces, and were not established in Newcastle until 1822. In his youth Bewick may well have seen little more than the work of local sign and coach painters, though his master's brother William Beilby, besides being a skilled painter in enamels on glass, practised as a drawing master in Newcastle in the late 1770s and may perhaps have been a source of practical knowledge.[2] Girtin and Turner were both travelling and painting in Northumberland in the 1790s, but there is no record of any contact they may have made. Sandby's work is unlikely to have been known to him beyond the numerous engravings after his drawings. Bewick clearly valued the contact he had with brother artists, but no strong thread of influence can be found. His pupil Clennell obviously developed most fully when he reached London; Johnson's career was cut short just as he was beginning to move away from Newcastle: the report that 'a lady in Newcastle, observing his taste and ability, was at the expense of keeping him at an academy for drawing' does not convince us that its influence was either long or fruitful. Although things had obviously improved by the late 1820s with the establishment of public exhibitions at the Northern Institution, in 1798 Bewick was still able to write to the engraver John Landseer that he believed that there were 'fewer admirers of Arts in NC than in any Town of its size in G^t Britain'.[3]

Towards the end of his *Memoir*, Bewick remarked that if he had been a painter he would never have

[1] William Bell Scott, *Autobiography*, 1860, ii. 194–6. [2] A number of William Beilby's small watercolour landscapes, now in a private collection, were given their first public exhibition at the Laing Gallery in 1980. [3] TB to John Landseer, 21 June 1798 (Pease Collection).

copied the works of old masters: 'I would have gone to nature for *all my patterns*, for she exhibits an endless variety – not possible to be surpassed & scarcely ever to be equalled',[1] but he did admit to the necessity for discovering the old masters' secrets to the mixing of their colours and their handling of light and shade. At the beginning of the same passage he laid out his proposals for the healthy and successful conduct of an artist's life:

The sedentary Artist ought if possible to have his dwelling in the country where he could follow his business undisturbed, surrounded by pleasing rural scenery & the fresh air and as 'all work & no play, makes Jack a dull Boy', he ought not to sit at it, too long at a time, but to unbend his mind with some variety of employment – for which purpose, it is desireable, that Artists, with their *little Cots*, should also have each a Garden attached in which they might find both exercise & amusement – and only occasionally visit the City or the smokey Town & that chiefly for the purpose of meetings with their Brother Artists in which they might make an interchange of their sentiments & commune with each other as to whatever regarded the Arts –....[2]

Few if any of his pupils did anything but stay firmly in the city, and for some no doubt the continuous influence of fellow artists and ready access to the sources of work was essential. For Bewick's own part, his work bench remained in the 'smokey Town' all his life, though his home was always within close reach of the open spaces – first on the outside of the Newcastle town wall, and latterly on the edge of Gateshead, with a view to the west and his birthplace on the Tyne. The refreshment of the countryside was his constant inspiration, and for his career as an artist, it was his salvation.

[1] *Memoir*, p.203. [2] *Memoir*, p.201.

FIGURES AND TAIL-PIECE VIGNETTES

FOR THE

GENERAL HISTORY OF

QUADRUPEDS

1790

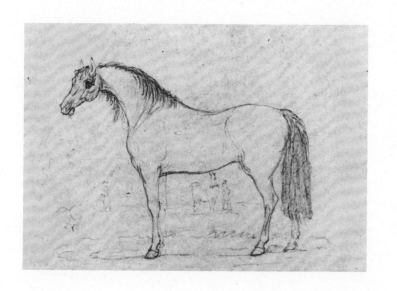
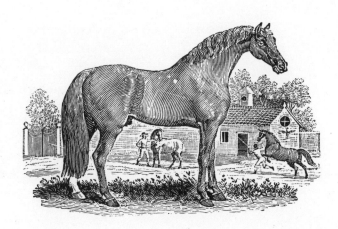

The Arabian Horse

Pencil. Transfer drawing by BEWICK for his engraving in *Quadrupeds*,
1791, p. 3. *Coll:* Pease Bequest.

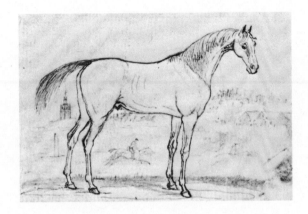
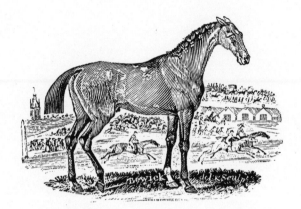

The Race-Horse

Pen and pencil. Study by BEWICK for his engraving in *Quadrupeds*, 1790, p. 4. On 10 November 1781 Bewick wrote to Squire Fenwick of Bywell for information on his famous horse 'Match 'Em' for inclusion in the newly conceived *History of Quadrupeds* (letter in the collection of Mr Greer Allen). It is interesting to see the animal's change of attitude in the engraving: the rear hoof raised and ready to kick, and the laid-back ears. In this Bewick may well have been influenced by the engraving of 'Match 'Em' after the painting by Wootton. Ironically Wootton's painting has in recent years been found to be of another animal, overpainted and renamed. This explains what would otherwise conflict with 'Match 'Em''s reputation quoted in Bewick's text: 'the quietest stallion that ever was known'. The spire of St Nicholas's Church in the background confirms that the scene is of one of the race meetings held on the Town Moor, Newcastle. *Coll:* Pease Bequest.

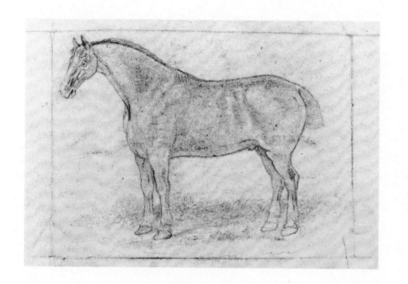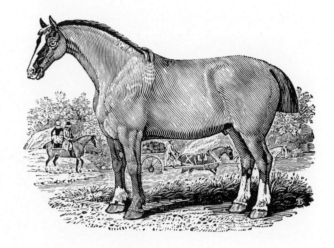

The Improved Cart-Horse

Pencil. Transfer drawing by BEWICK for his engraving in *Quadrupeds*,
1800, p. 14. Drawn from a horse owned by George Baker of Elemore,
County Durham. *Coll:* Pease Bequest.

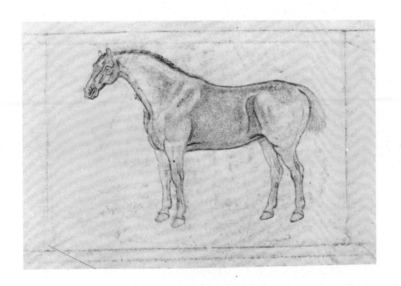

The Old English Road-Horse

Pencil. Transfer drawing by BEWICK for his engraving in *Quadrupeds*, 1800, p. 9. The trotting horse in the background shows that Bewick had mastered the portrayal of this action; the galloping animals seen in the background to the figure of the Racehorse still appear in the earlier inaccurate convention with paired legs stretched to front and rear. *Coll:* Pease Bequest.

The Kyloe Ox

Pencil. Transfer drawing by BEWICK for his engraving in *Quadrupeds*,
1791, p. 31. A Highland drover in his plaid can be seen in the background:
a familiar sight in the Northumberland of Bewick's time. The Kyloe cattle
bred in the Highlands and Western Isles of Scotland were sold in great
numbers at the border and northern fairs. *Coll:* Pease Bequest.

The Tees-Water Old, or Unimproved Breed

Pencil. Transfer drawing by BEWICK for his engraving in *Quadrupeds*, 1800, p. 60: 'Our figure was taken in July 1798 from a Ram which had been purchased for the purpose of shewing its uncouth and uncultivated appearance, in contrast to those of the improved kind.' Engraved during the week ending 17 November 1798 at a charge to the business of £1.11s.6d. (R. 35 Laing). *Coll:* Natural History Society of Northumbria.

The Tees-Water Improved Breed

Pencil. Transfer drawing by BEWICK for his engraving in *Quadrupeds*, 1800, p. 61. Engraved during the week ending 8 December 1798 at a charge to the business of £1.11s.6d. (R. 35 Laing). *Coll:* Pease Bequest.

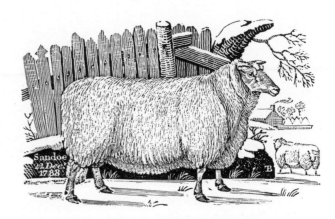

The Leicestershire Improved Breed

Pencil. Transfer drawing by BEWICK for his engraving in *Quadrupeds*, 1790, p. 43. Inscribed in Jane Bewick's hand: 'T Bewick'. The date of the portrait is cut in the engraving: 'Sandoe, 22 Decr 1788'; the drawing was made from a ram in the flock of Donkin & Co, of Hexham brewery. Sandhoe village is $2\frac{1}{2}$ miles from Hexham. *Coll:* Natural History Society of Northumbria.

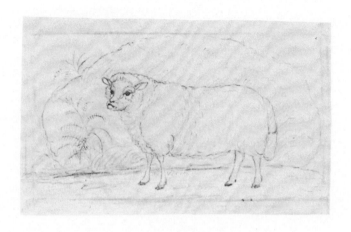

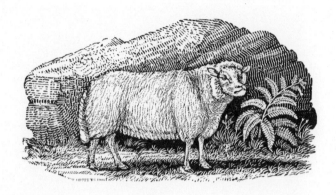

The Dunkey, or Dwarf Sheep

Pencil. Transfer drawing by BEWICK for his engraving in *Quadrupeds*,
1790, p. 46. *Coll:* Pease Bequest.

The Rhinoceros

Pencil. Study by BEWICK for his engraving in *Quadrupeds*, 1790, p. 141.
Coll: Natural History Society of Northumbria.

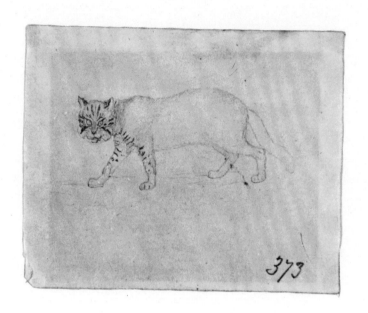

The Wild Cat

Pencil. Study by BEWICK for his engraving in *Quadrupeds*, 1790, p. 189.
Coll: Natural History Society of Northumbria. (Another pencil study is in
the same collection. Not reproduced.)

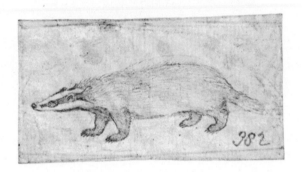

The Badger

Pencil. Transfer drawing by BEWICK for his engraving in *Quadrupeds*,
1790, p. 238. The monogram TB removed from the block in later editions.
Coll: Natural History Society of Northumbria.

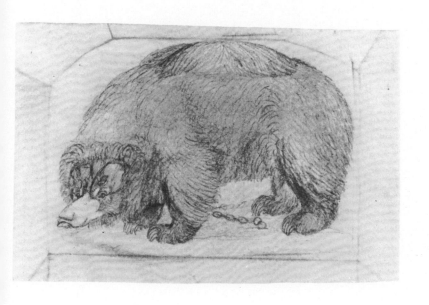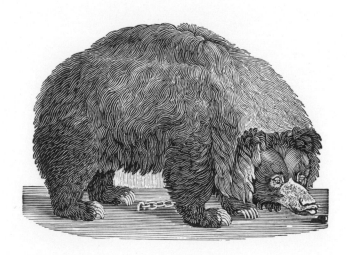

Un-named Bear from Bengal

Pencil. Transfer drawing by BEWICK for his engraving in *Quadrupeds*, 1791, p. 266: '. . . drawn from the life' – presumably from an animal in a travelling menagerie. *Coll:* Pease Bequest.

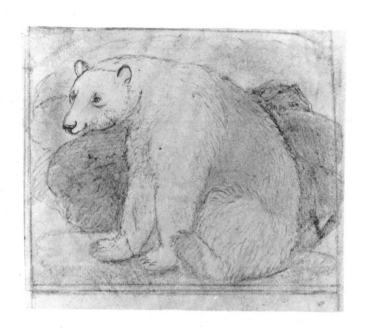

The Polar or Great White Bear

Pencil. Transfer drawing by BEWICK for his engraving in *Quadrupeds*, 1791, p. 268. *Coll:* Pease Bequest.

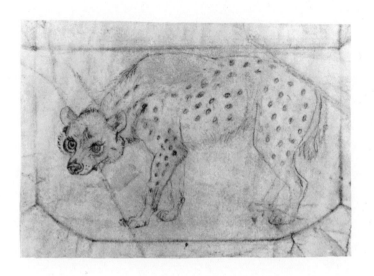

The Spotted Hyena

Pencil. Transfer drawing by BEWICK for his engraving in *Quadrupeds*, 1800. p. 301: 'Our figure was drawn from a male Hyena exhibited in Newcastle in the spring and summer of 1799', probably in Gilbert Pidcock's travelling menagerie from Exeter 'Change, in the Strand, London which was in the north at this time. Correspondence in the Editor's collection relates to Bewick's engraving commissions from Pidcock. *Coll:* Pease Bequest.

The Cur Fox

Pencil. Transfer drawing by BEWICK for his engraving in *Quadrupeds*,
1790, p. 270. *Coll:* Natural History Society of Northumbria.

The Shepherd's Dog

Pencil. Transfer drawing by BEWICK for his engraving in *Quadrupeds*, 1790, p. 284: 'This breed of Dogs, at present, appears to be preserved, in the greatest purity, in the northern parts of Scotland...'. The Highland shepherd in his bonnet and plaid can be seen in the background. *Coll:* Pease Bequest.

The Cur Dog

Pencil. Transfer drawing by BEWICK for his engraving in *Quadrupeds*, 1790 p. 286. 'They bite very keenly; and as they always make their attack at the heels, the cattle have no defence against them: in this way, they are more than a match for a Bull, which they quickly compel to run' – as seen in the background to the engraving. *Coll:* Pease Bequest.

The Mastiff

Pencil. Transfer drawing by BEWICK for his engraving in *Quadrupeds*, 1790, p. 291. Seventeen dogs of various breeds can be seen in the background of the engraving. *Coll:* Pease Bequest.

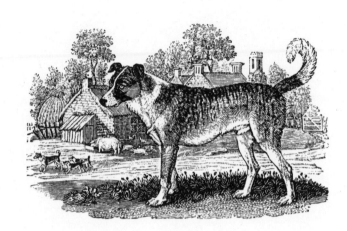

The Ban-Dog

Pencil. Study by BEWICK for his engraving in *Quadrupeds*, 1790,
p.300. *Coll:* Natural History Society of Northumbria.

The Harrier

Pencil. Transfer drawing by BEWICK for his engraving in *Quadrupeds*, 1791, p. 317. In the engraving the dog's collar carries the name 'Lt Col Pitts'; the initials branded on its side, 'GC', are probably those of George Culley, 1735–1813, the celebrated Northumbrian livestock improver and agriculturalist, of Fowberry Tower near Belford. *Coll:* Newberry Library, Chicago.

The Long-Tailed Squirrel

Pencil. Transfer drawing by BEWICK for his engraving in *Quadrupeds*, 1791, p. 363. Taken from a drawing supplied by Thomas Pennant (1726–98), traveller and naturalist, and author on his own account of a *History of Quadrupeds*, 1781. *Coll:* Natural History Society of Northumbria.

The Domestic Rabbit

Pencil. Transfer drawing by BEWICK for his engraving in *Quadrupeds*,
1790, p. 327. *Coll:* Natural History Society of Northumbria.

The Long-Tailed Fieldmouse

Pencil. Study by BEWICK for his engraving in *Quadrupeds*, 1790, p. 361.
Inscribed in Bewick's hand: 'Field Mouse Male'. *Coll:* Natural History
Society of Northumbria.

The Mole

Pencil. Transfer drawing by BEWICK for his engraving in *Quadrupeds*,
1790, p. 365. *Coll:* Pease Bequest.

The Squirrel Opossum

Pencil. Transfer drawing by BEWICK for his engraving in *Quadrupeds*, 1790, p. 376. 'We are favoured with a drawing of this beautiful animal, taken from a living one in the possession of the reverend Mr Egerton, prebendary of Durham, by the ingenious Mr Carfrae.' *Coll:* Pease Bequest.

The Llama

Pencil and light wash. Study by BEWICK for the subject described in but never engraved for *Quadrupeds*. Inscribed in Bewick's hand 'black Legs & feet'. *Coll:* British Museum.

The Ouistiti, or Cagvi

Pencil. Transfer drawing by BEWICK for his engraving in *Quadrupeds*,
1790, p. 415: 'Mr Edwards gives a description of one of these animals,
accompanied with an excellent figure' – which was probably Bewick's
source for his own drawing. George Edwards (1694–1773), published
Gleanings of Natural History in 3 volumes between 1758 and 1764. In
later editions renamed the Striated Monkey. *Coll:* Pease Bequest.

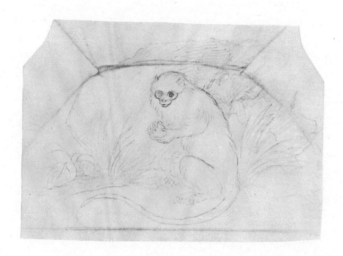

The Mico, or Fair Monkey

Pencil. Transfer drawing by BEWICK for his engraving in *Quadrupeds*,
1790, p. 418. *Coll:* Pease Bequest.

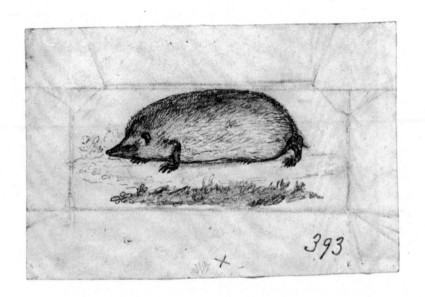

The Hedge-Hog, or Urchin

Pencil. Transfer drawing by BEWICK for his engraving in *Quadrupeds*,
1790, p. 423. *Coll:* Natural History Society of Northumbria.

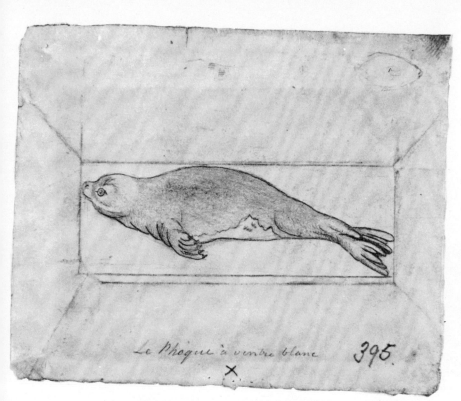

Le Phoque à ventre blanc 395.

The Seal

Pencil. Transfer drawing by BEWICK for his engraving in *Quadrupeds*, 1790, p. 449. Inscribed in Bewick's hand: 'La Phoque à ventre blanc' – perhaps evidence of his reliance on the works of the Comte de Buffon for some of his text description. *Coll:* Natural History Society of Northumbria.

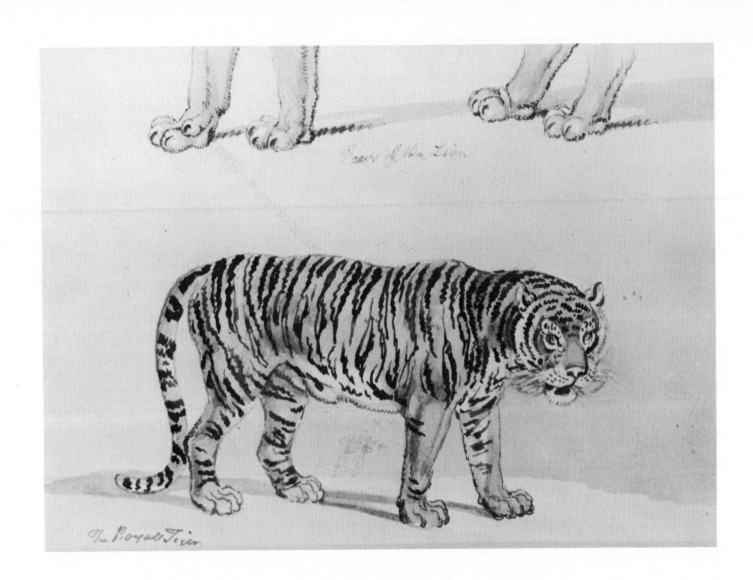

The Tiger

Pen and wash. Study by BEWICK possibly for the engraving commissioned by Pidcock, the menagerie proprietor, in 1799. See introduction, p. 31. Inscribed in Bewick's hand 'The Royal Tiger' and, under the details drawn in the upper part of the sheet, 'Paws of the Lion'. *Coll:* Laing Art Gallery (drawing); Iain Bain (engraving – colour-washed by Bewick).

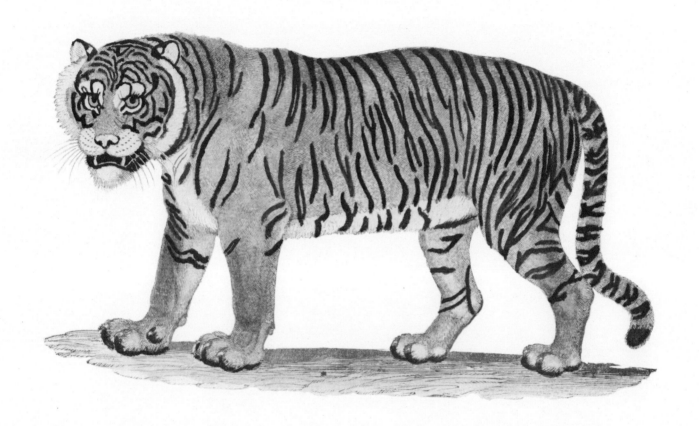

A Thirsty Cow

Pencil. Transfer drawing by BEWICK for his tail-piece engraving in
Quadrupeds, 1791, p. 33. The engraving adds the detail showing the
fence broken down by the cow in her efforts to reach the water. *Coll:*
Pease Bequest.

Two Blind Fiddlers

Pencil. Transfer drawing by BEWICK for his tail-piece engraving in
Quadrupeds, 1790, p. 456. Led by a boy holding out a hat for alms, they
are approaching the gates of a rich man's mansion. Although the boy
can see, he cannot read the warning sign on the wall which appears in
the engraving: 'Steel Traps – Spring Guns.' A pencil study for the same
subject in the Newberry Library, Chicago (not reproduced), has the
leading musician playing a reeded pipe. *Coll:* Natural History Society
of Northumbria.

A Man relieving himself behind a Wall

'FIAT OPUS'

Pencil. Transfer drawing by BEWICK for his tail-piece engraving in
Quadrupeds, 1791, p. 250. Inscribed in Bewick's hand 'FIAT OPUS' [let
the work be done]. The woman passing by is holding her nose, assailed
by smells. A smoking kiln is seen in the distance. *Coll:* Pease Bequest.

A Crouching Leopard about to Spring

Pencil. Transfer drawing by BEWICK for his tail-piece engraving in
Quadrupeds, 1792, p. 192. *Coll:* Pease Bequest.

An Itinerant Showman with his Performing Animals

Pencil. Transfer drawing by BEWICK for his tail-piece engraving in *Quadrupeds*, 1790, p. 256. The background in the drawing shows the skyline of Newcastle and a gibbet – sign of Bewick's disapproval of the cruelty of the showman. *Coll:* Pease Bequest.

Resting by the Wayside for Refreshment

Pencil. Transfer drawing by BEWICK for his tail-piece engraving in
Quadrupeds, 1790, p. 285. *Coll:* Pease Bequest.

A Cat at Bay

Pencil. Transfer drawing by BEWICK for his tail-piece engraving in
Quadrupeds, 1790, p. 195. *Coll:* Pease Bequest.

A Man driving a Sow

Pencil. Transfer drawing by BEWICK for his tail-piece engraving in
Quadrupeds, 1790, p. 371. Some trial initial letters probably for an
unrelated copper engraving can be seen along the lower edge of the
paper. *Coll:* Pease Bequest.

A Travelling Beggar fording a River

Pencil. Transfer drawing by BEWICK for his tail-piece engraving in *Quadrupeds*, 1791, p. 121. Chatto (p. 578): 'An excellent satire on those old men who marry young wives and become dotingly uxorious in the decline of life, submitting to every indignity to please their youthful spouses and reconcile them to their state.' The old man is wearing a parson's cast-off beaver and wig. The landscape is reminiscent of the River Tyne with Ovingham Church in the distance. *Coll:* Pease Bequest.

A Stag drinking at a Spring

'OMNE BONUM DESUPER' 'OPERA DEI MIRIFICA'

Pencil. Transfer drawing by BEWICK for his engraving in *Quadrupeds*,
1790, title-page. The inscription on the two faces of the rock read: 'All
good from above' and 'The works of God are wonderful'. *Coll:* Pease
Bequest.

FIGURES AND TAIL-PIECE VIGNETTES

FOR THE

HISTORY OF BRITISH

BIRDS

1797–1804

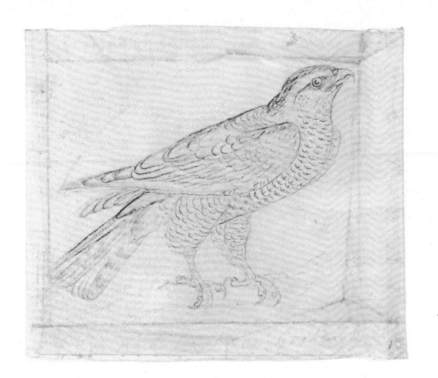

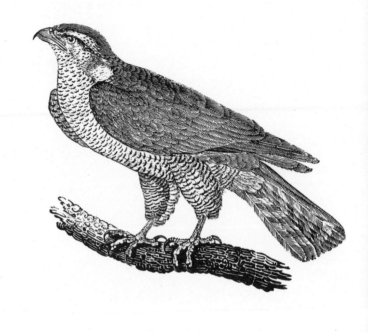

The Goshawk

Pencil. Transfer drawing by BEWICK for his engraving in *British Birds*
Vol. 1, 1797, p. 23. *Coll:* Natural History Society of Northumbria.

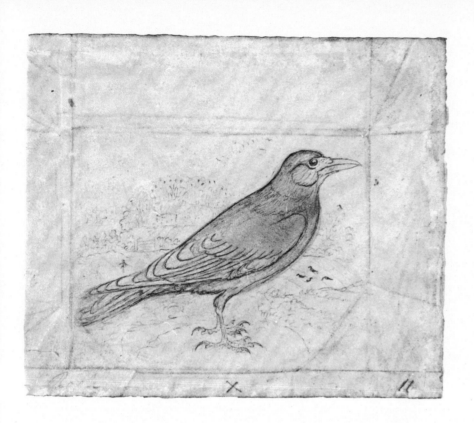

The Rook

Pencil. Transfer drawing by BEWICK for his engraving in *British Birds*
Vol. 1, 1797, p. 72. *Coll:* Natural History Society of Northumbria.

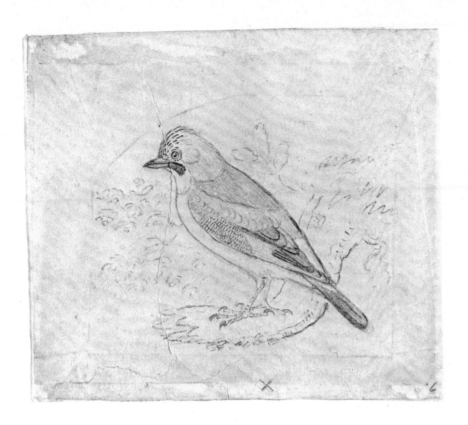

The Jay

Pencil. Transfer drawing by BEWICK for his engraving in *British Birds*
Vol. I, 1797, p. 80. *Coll:* Natural History Society of Northumbria.

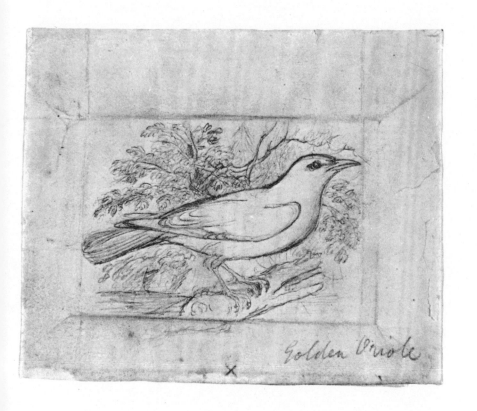

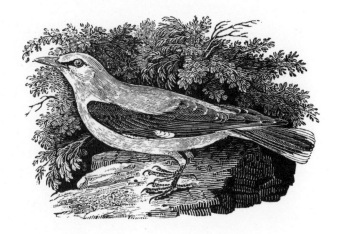

The Golden Thrush

GOLDEN ORIOLE

Pencil. Transfer drawing by BEWICK for his engraving in *Supplement to the History of British Birds* Part I, 1821, p. 20: 'The skin of the male was presented to this work by G. T. Fox esq of Westoe: the bird was shot as it was approaching our shore in the English Channel. A pair, male and female, were also lent for the same purpose by the Honourable Mr Liddell from his Museum at Ravensworth Castle, and from these and the foregoing, our description and figure were taken.' Inscribed 'Golden Oriole' probably in the hand of John Hancock. *Coll:* Natural History Society of Northumbria.

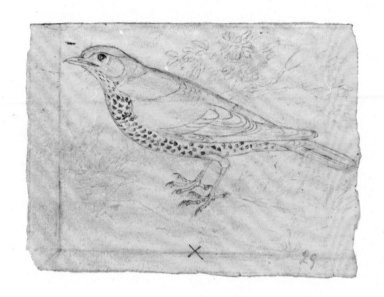
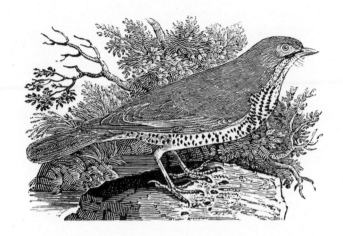

The Missel Thrush

MISSEL BIRD, or SHRITE

Pencil. Transfer drawing by BEWICK for his engraving in *Supplement to the History of British Birds* Part I, 1821, p. 18. *Coll:* Natural History Society of Northumbria.

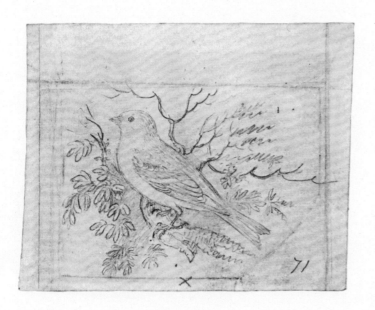

The Lesser Redpole

Pencil. Transfer drawing by BEWICK for his engraving in *British Birds*
Vol. 1, 1797, p. 174. *Coll:* Natural History Society of Northumbria.

The Gray Wagtail

Pencil. Transfer drawing by Bewick for his engraving in *British Birds*
Vol. 1, 1797, p. 190. *Coll:* Natural History Society of Northumbria.

The Lesser White-Throat

Pencil. Transfer drawing by BEWICK for his engraving in *Supplement to the History of British Birds* Part I, 1821, p. 39. *Coll:* Natural History Society of Northumbria.

The Lesser Fauvette

PASSERINE WARBLER

Pencil. Transfer drawing by BEWICK for his engraving in *British Birds* Vol. 1, 1797, p. 212. Inscribed 'Garden Warbler' probably in the hand of John Hancock. *Coll:* Natural History Society of Northumbria.

The Crested Tit

Pencil. Transfer drawing by BEWICK for his engraving in *Supplement to the History of British Birds* Part I, 1821, p. 41: 'The above figure was made from a stuffed specimen obligingly lent to this work by the Hon H. T. Liddell of Ravensworth Castle.' *Coll:* Natural History Society of Northumbria.

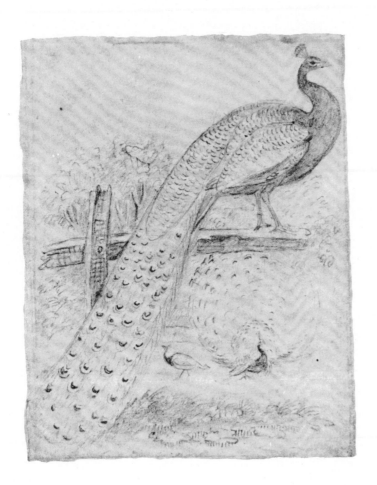 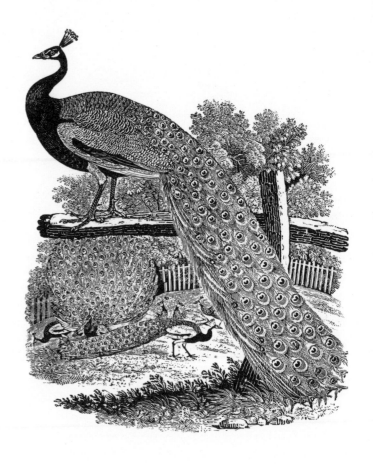

The Peacock

Pencil. Transfer drawing by BEWICK for his engraving in *British Birds*
Vol. 1, 1797, p. 289. *Coll:* Natural History Society of Northumbria.

The Corn-Crake

LAND RAIL, or DAKER HEN

Pencil. Transfer drawing by BEWICK for his engraving in *British Birds*
Vol. 1, 1797, p. 311: 'Our figure was made from the living bird sent us
by Lieut. H. F. Gibson' – domesticated in Bewick's house at the Forth
(Robinson, pp. 100–1) and later preserved in an attractively decorated
oval glass case by Richard Wingate, Newcastle taxidermist and friend
of Bewick. The case is now in the collection of the Pease Bequest. *Coll:*
Natural History Society of Northumbria.

The Partridge

Pencil. Transfer drawing by BEWICK for his engraving in *British Birds*
Vol. 1, 1797, p. 305. *Coll:* Natural History Society of Northumbria.

The Guernsey Partridge

RED-LEGGED PARTRIDGE

Pencil. Transfer drawing by BEWICK for his engraving in *Supplement to the History of British Birds* Part I, 1821, p. 43. *Coll:* Natural History Society of Northumbria.

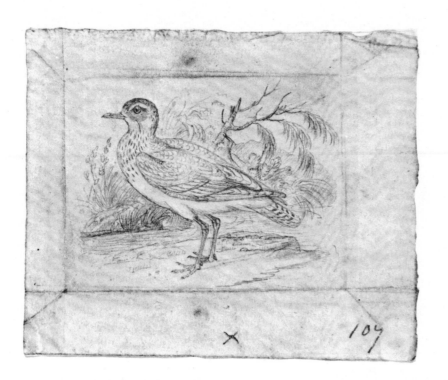

The Grey Plover

Pencil. Transfer drawing by BEWICK for his engraving in *Supplement to the History of British Birds* Part I, 1821, p.49. *Coll:* Natural History Society of Northumbria.

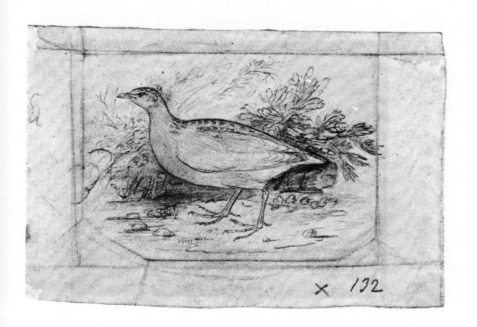

The Water Crake

SPOTTED RAIL, SPOTTED WATER RAIL, SKITTY,
or SPOTTED GALLINULE

Pencil. Transfer drawing by BEWICK for his engraving in *British Birds*
Vol. 2, 1804, p. 10. *Coll:* Natural History Society of Northumbria.

The Water Ouzel

WATER CROW, DIPPER, or WATER PIOT

Pencil. Transfer drawing by BEWICK for his engraving in *British Birds* Vol. 2, 1804, p. 16. *Coll:* Natural History Society of Northumbria. (Pen and watercolour study in same collection. Not reproduced.)

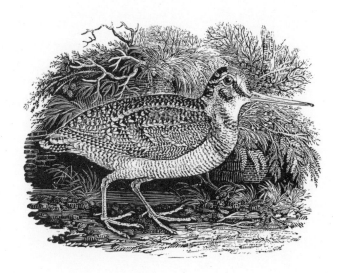

26 by 21 X 126

The Woodcock

Pencil. Transfer drawing by BEWICK for his engraving in *British Birds*
Vol. 2, 1804, p. 60. Engraved during the week ending 7 March 1801: 'Wood
Cock TB' (R. 35 Laing). *Coll:* Natural History Society of Northumbria.

The Little Stint

LITTLE SANDPIPER, or LEAST SNIPE

Pencil. Transfer drawing by BEWICK for his engraving in *British Birds* Vol. 2, 1804, p. 122: 'This figure and description were taken from a bird shot by Robert Pearson Esq. of Newcastle, on 10 September 1801.' A presumably discarded block engraved during the week ending 29 March 1800 at a charge to the business of £1.1s. A new block engraved from this drawing during the week ending 7 November 1801 after the receipt of Pearson's specimen (R. 35 Laing). *Coll:* Natural History Society of Northumbria.

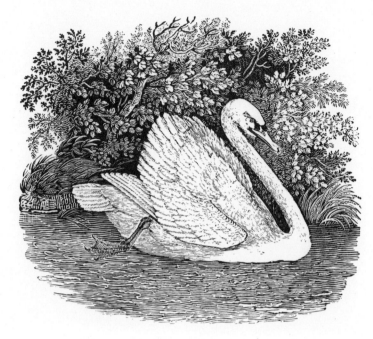

The Mute Swan

TAME SWAN

Pencil. Transfer drawing by BEWICK for his engraving in *British Birds*
Vol. 2, 1804, p. 277. *Coll:* British Museum.

[155]

The Newcastle Arms on a Boundary Stone

Pencil. Study by Bewick for his engraving in *British Birds* Vol. 1, 1797, title-page. Robinson (p. 180): 'A fine blackbird apropos of coaly Tyne.' Keel boats (coal transporters) can be seen on the River Tyne – they were known as 'the black fleet'; and on the distant south bank, the Windmill Hills near Gateshead. The trial lettering on the drawing in Bewick's hand – Newcastle Printed by S. Hodgson for Beilby & Bewick 1790 – show that it was first intended for the title of the *Quadrupeds*. *Coll:* Natural History Society of Northumbria.

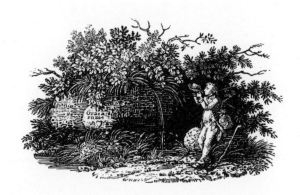

A Countryman drinking at a Spring

'GRATA SUME'

Pencil. Transfer drawing by BEWICK for his tail-piece engraving in *British Birds* Vol. I, 1797, pp. xxx and 177. The inscription on the rock reads: 'Thanks be to the Highest' with a heart cut below. All that can be seen of the inscription in the drawing is a capital W–– perhaps the beginnings of 'Wonderful are Thy works'. The man is drinking from the 'flipes' or brim of his hat. *Coll:* Natural History Society of Northumbria.

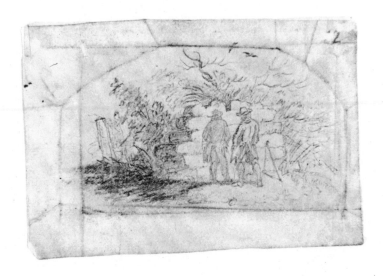
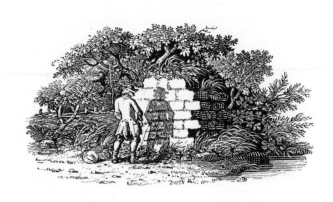

Roadside Relief

Pencil. Transfer drawing by Bewick for his tail-piece engraving in *British Birds* Vol. 1, 1797, p. 42. *Coll:* Natural History Society of Northumbria.

 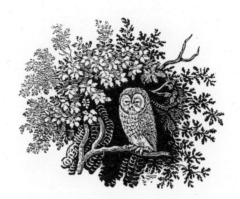

A Barn Owl

Pencil. Transfer drawing by BEWICK for his tail-piece engraving in *British
Birds* Vol. 1, 1797, p. 55. *Coll:* British Museum.

The 'George Cowie' Scarecrow

Pencil and wash. Study by BEWICK for his tail-piece engraving in *British Birds* Vol. 1, 1826, p. 82. *Memoir* (p. 31): 'Cowie appeared occasionally in his old Military Coat &c as long as he lived, & after he died this coat, which had been shot at both at Minden and elsewhere, was, at last hung up – on a Stake on the corn Rigs as a scare Crow'. *Coll:* British Museum.

'Joe Liddell tracing a Hare'

Pencil. Transfer drawing by BEWICK for his tail-piece engraving in *British Birds* Vol. 1, 1797, p. 147. The title is from Jane Bewick's MS. Liddell was a boyhood friend of Bewick who is himself portrayed across the distant field behind a hedge. Liddell uses the tail of his coat to protect the gun's flintlock from the damp. *Coll:* Natural History Society of Northumbria.

An Old Woman meeting a Bull at a Stile

Pencil. Transfer drawing by BEWICK for his tail-piece engraving in *British Birds* Vol. 2, 1847, p. 90. *Coll:* British Museum.

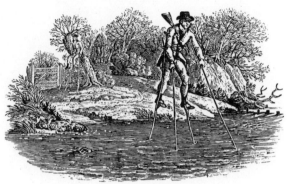

Two Sportsmen crossing a River on Stilts

Pencil. Transfer drawing by BEWICK for his tail-piece engraving in *British Birds* Vol. 2, 1804, p. 5. Engraved during the week ending 28 September 1799 at a charge to the business of £1.1s. (R. 35 Laing). The engraving omits the heron flying overhead. *Coll:* Newberry Library, Chicago.

An Angler on a River Bank

Pencil. Transfer drawing by BEWICK for his tail-piece engraving in *British Birds* Vol. 1, 1797, p. 216. *Coll:* Natural History Society of Northumbria.

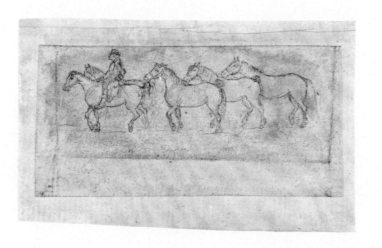

'Horses to Market'

Pencil. Transfer drawing by BEWICK for his tail-piece engraving in *British Birds* Vol. 1, 1826, p. 378. Jane Bewick's MS (p. 10): 'Taking his horses to market – Three of the animals have their beautiful flowing tails, two are *docked*, and one on which the old fellow rides is *nicked*. – ' *Coll:* Natural History Society of Northumbria. (Pencil study in private collection, USA. Not reproduced.)

The Yoked Sow and the Thieving Piglets

Pencil. Transfer drawing by BEWICK for his tail-piece engraving in *British Birds* Vol. 1, 1826, p. 370. Engraved 2 July 1824, dated thus on underside of original block (Private collection, Detroit, USA). Written in Bewick's hand on a proof in the Editor's collection: 'How can ye expect the bairns will be honest when the mother's a thief?'. *Coll:* Natural History Society of Northumbria.

A Tinker and his Wife travelling on a Windy Day

Pencil and wash. Transfer drawing by ? JOHNSON for the tail-piece
engraving by HOLE in *British Birds* Vol. 2, 1804, p. 176. Chatto (p. 588)
records drawing by Johnson, engraving by Hole; (MS.f.30ᵛ) engraving
by Hole. *Coll:* British Museum.

'A Wonderful Fish'

Pencil and wash. Transfer drawing by ? CLENNELL for his tail-piece engraving in *British Birds* Vol. 2, 1804, p. 373. Engraved during the week ending 8 November 1800 (R. 35 Laing). Though used for transfer, the drawing was probably applied to a subsequently discarded block: it is larger, and the position of the church spire is different. *Coll:* British Museum.

A Traveller and his Dog on a Windy Day

Pencil. Transfer drawing by BEWICK for the tail-piece engraving by HOLE
in *British Birds* Vol. 2, 1804, p. 251. Chatto (p. 588) records engraving by
Hole; (MS.f.30) drawing by Johnson, engraving by Hole. *Coll:* Natural
History Society of Northumbria.

The Churchyard Cavalry

Pencil and wash. Transfer drawing by ? CLENNELL for his tail-piece engraving in *British Birds* Vol. 2, 1804, p. 304. Possibly engraved during the week ending 27 June 1801: 'Church-Yard Tail piece' (R.35 Laing). This entry may refer to the tombstone tail-piece inscribed 'Good Times & Bad Times & All Times Get Over' in Vol. 2, p. 166. Chatto (MS.f28ᵛ) records drawing by Johnson, engraving by Clennell. The hierarchy of army rank is reflected in the dress of the boys: the squire's son and parson's son who lead are well dressed and shod; their poorer companions following behind are barefooted and less smartly clad. *Coll:* British Museum.

FIGURES AND TAIL-PIECE VIGNETTES
FOR THE
FABLES OF AESOP
AND OTHERS
1818

The Husbandman and his Sons

Pencil and wash. Study by ? JOHNSON of the subject engraved by an apprentice in *Fables of Aesop*, 1818, p. 15. The differing proportions of the oval shape suggest that the drawing was for an earlier series of fables not yet identified. Attributed to Robert Bewick by Jane Bewick; his initials R E B inscribed in her hand. Design derived from Croxall. *Coll:* British Museum.

Hercules and the Carter

Pencil and wash. Study by ? JOHNSON of the subject engraved by an apprentice in *Fables of Aesop*, 1818, p. 37. Engraved during the week ending 21 January 1815 (V & A 1815–19). The differing proportions of the oval shape suggest that the drawing was for an earlier series of fables not yet identified. Design derived from Croxall. *Coll:* Natural History Society of Northumbria.

The Wolf, the Fox and the Ape

Pencil. Transfer drawing by BEWICK for the apprentice engraving in *Fables of Aesop*, 1818, p. 85. *Coll:* Natural History Society of Northumbria.

The Fowler and the Lark

Pencil. Transfer drawing by BEWICK for the apprentice engraving in *Fables of Aesop*, 1818, p. 355. *Coll:* Natural History Society of Northumbria.

The Old Lion

Pencil. Transfer drawing by BEWICK for the apprentice engraving in *Fables of Aesop*, 1818, p. 211. *Coll:* Natural History Society of Northumbria.

The Old Lion

Pen and wash. Transfer drawing by ? HARVEY for an unpublished engraving
for *Fables of Aesop*, 1818. Second version. Design derived from Croxall. *Coll:*
Natural History Society of Northumbria.

The Dog and the Wolf

Pencil and wash. Study by ? JOHNSON of the subject engraved by an
apprentice in *Fables of Aesop*, 1818, p. 287. Engraved during the week
ending 30 July 1814 (V & A 1815–19). The differing proportions of the
oval shape suggest that the drawing was for an earlier series of fables not
yet identified. *Coll:* Natural History Society of Northumbria. (Another,
similar, study in the same collection: not reproduced.)

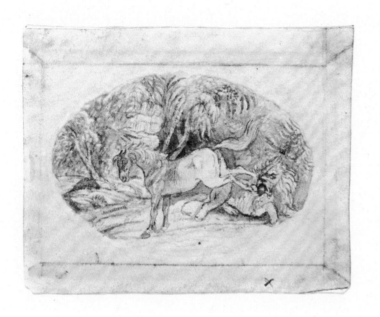
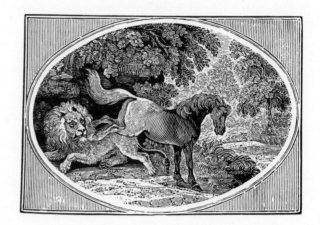

The Horse and the Lion

Pencil and wash. Transfer drawing by BEWICK for the apprentice engraving in *Fables of Aesop*, 1818, p. 309. Design derived from Croxall. Engraved during the week ending 29 November 1817 (V & A 1815–19). *Coll:* Natural History Society of Northumbria.

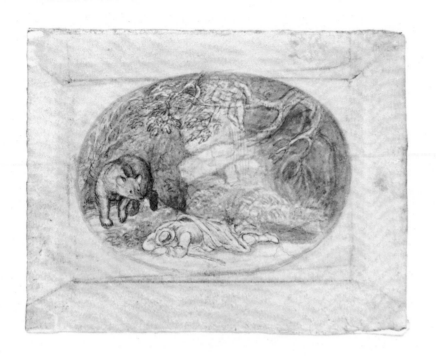

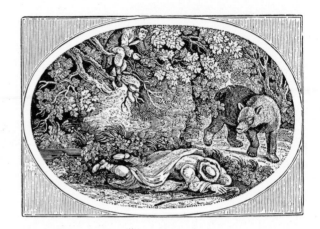

The Travellers and the Bear

Pencil. Transfer drawing by BEWICK for the apprentice engraving in *Fables of Aesop*, 1818, p. 347. Design derived from Croxall. Engraved during the week ending 13 June 1818 (V & A 1815–19). *Coll:* Natural History Society of Northumbria.

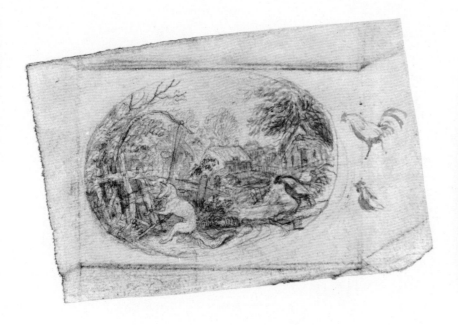 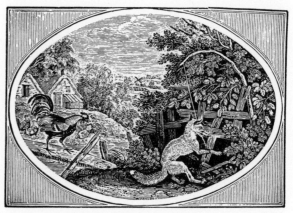

The Cock and the Fox

Pencil. Transfer drawing by BEWICK for the apprentice engraving in *Fables of Aesop*, 1818, p. 359. Engraved during the week ending 5 July 1817 (V & A 1815–19). *Coll:* Natural History Society of Northumbria.

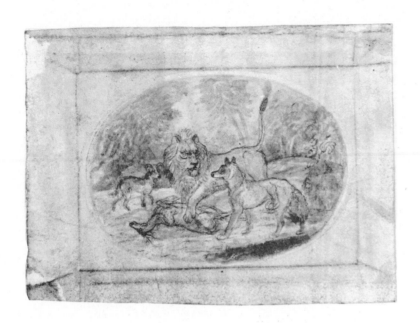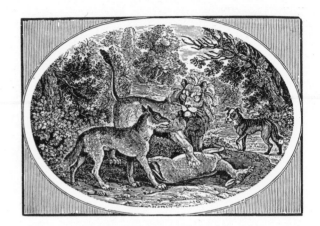

The Lion, the Wolf and the Dog

Pencil and wash. Transfer drawing by BEWICK for the apprentice engraving in *Fables of Aesop*, 1818, p. 367. Engraved during the week ending 30 May 1818 (V & A 1815–19). *Coll:* Natural History Society of Northumbria.

The Ass eating Thistles

Pencil, ink and wash. Transfer drawing by BEWICK for the apprentice engraving in *Fables of Aesop*, 1818, p. 369. Engraved during the week ending 19 September 1818 (V & A 1815–19). *Coll:* Natural History Society of Northumbria. (Pencil transfer drawing, unpublished, in same collection. Not reproduced. An un-engraved block carrying this design was offered for sale by Jane Bewick to Edward Ford in 1853 (Ford MSS).)

A Funeral at Ovingham

Pencil and wash. Transfer drawing by BEWICK for the tail-piece engraving by ? TEMPLE in *Fables of Aesop*, 1818, p. 376: 'Finis' to final page. Engraved during the week ending 22 August 1818 (V & A 1815–19). Reminiscent of Ovingham Church; not reversed for engraving. Heedless of the solemn procession, the local landowner takes his drink in the saddle outside the inn (see Vol. 2, p. 141). *Coll:* Natural History Society of Northumbria.

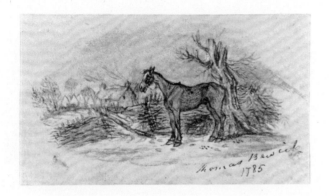

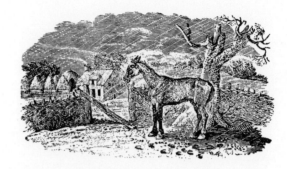

Waiting for Death

'Waiting for Death'

Pencil and wash. Study by BEWICK for his tail-piece engraving in *Fables of Aesop*, 1818 p. 338. Engraved during the week ending 3 August 1816 (V & A 1815–19). Inscribed in Jane Bewick's hand: 'Thomas Bewick 1785.' The title engraved in facsimile of Bewick's hand. This echoes the theme of Bewick's large and final engraving in progress and proofed just before his death. *Coll:* British Museum.

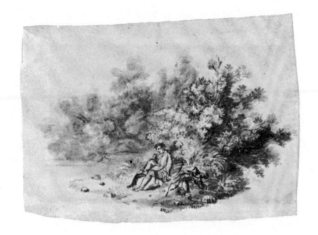 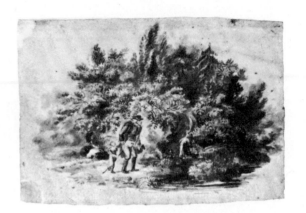

A Man dressing after Bathing

An Old Man and a Boy at a Spring

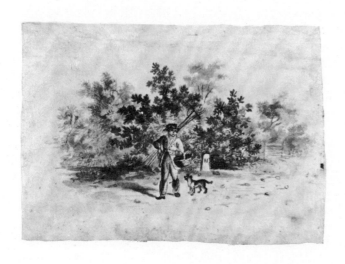

A Farm Labourer and his Dog

Pencil and wash. Transfer drawing by ? HARVEY for the apprentice tail-piece engraving in *Fables of Aesop*, 1818, p. 202. Two similar studies by the same hand are shown opposite; another is reproduced in Vol. 2, p. 230. *Coll:* Natural History Society of Northumbria.

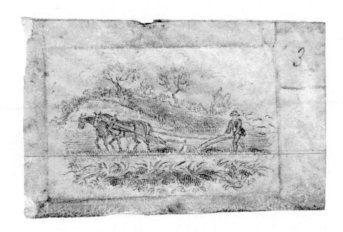

A Ploughman

Pencil. Transfer drawing by ROBERT BEWICK for the apprentice tail-piece engraving in *Fables of Aesop*, 1818, p. 224. Based on the subject engraved in *British Birds* Vol. 2, 1804, p. 157. *Coll:* Natural History Society of Northumbria.

FIGURES AND TAIL-PIECE VIGNETTE

FOR THE

HISTORY OF BRITISH

FISHES

The John Dory

Pencil. Study by ROBERT BEWICK for the engraving by JACKSON for the intended *British Fishes*; first published in Bewick's *Memoir*, 1862, p. 297. Signed in Robert Bewick's hand: 'R E Bewick del'. Pencil grid drawn for reduction. Chatto (p. 599) records engraving as 'an early performance of Mr Jackson's'. *Coll:* British Museum.

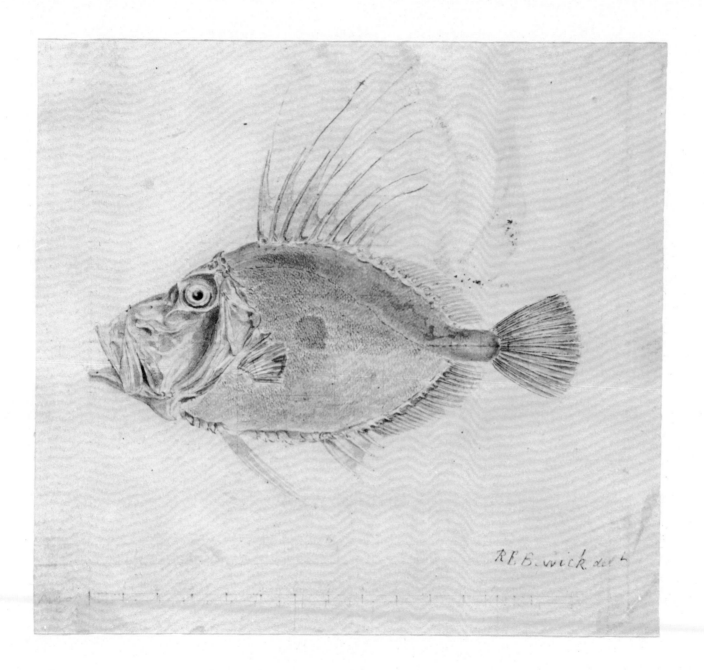

R.E.Bewick delt

The Ballan Wrasse

Pencil and watercolour. Study by ROBERT BEWICK for ? his engraving for the intended *British Fishes*; first published in Bewick's *Memoir*, 1862, p. 301. Inscribed in Robert Bewick's hand 'Labrus tinca' together with his enumeration of the fin spines. *Coll:* British Museum.

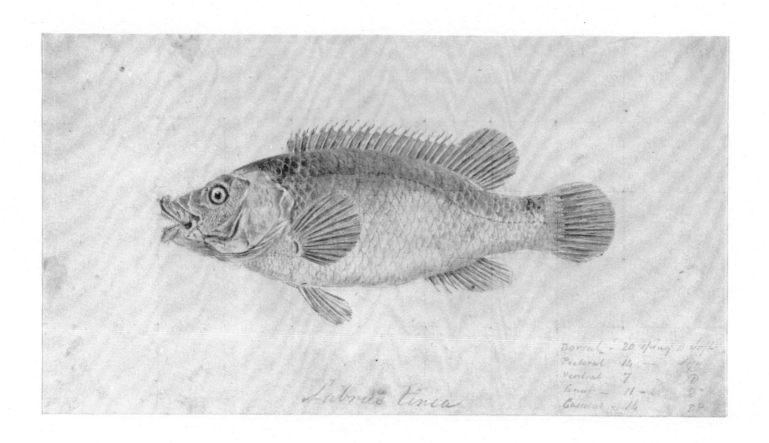

Labrus tinca

Dorsal – 20 spring 1 soft
Pectoral 14
Ventral 7
Anal – 11
Caudal – 14

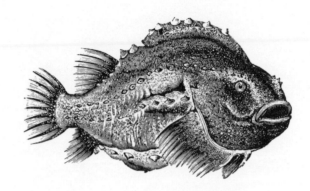

The Lump Sucker

Pen, pencil and wash. Study by ROBERT BEWICK for ? his engraving for
the intended *British Fishes*; first published in Bewick's *Memoir*, 1862,
p. 317. Title inscribed in Robert Bewick's hand. Pencil grid drawn for
reduction. *Coll:* British Museum.

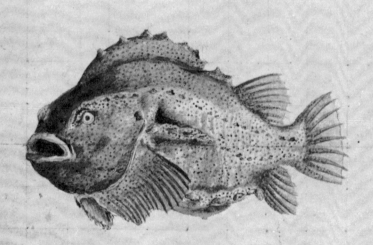

Order Branchiostegi

Genus Cyclopterus

C. Lumpus

Lump Sucker

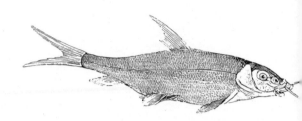

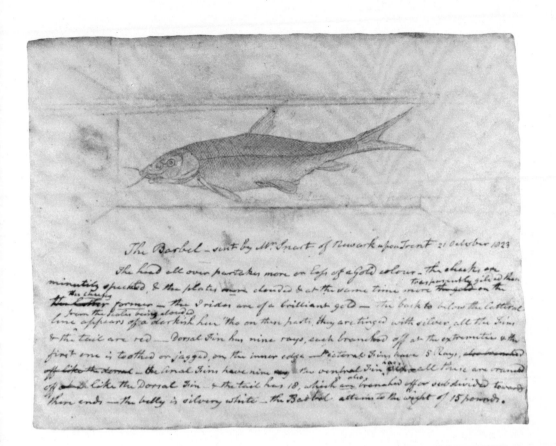

The Barbel — sent by Mr Snart of Newark upon Trent 21 October 1823

The head all over partakes more or less of a gold colour — the cheeks are minutely speckled, & the plates are clouded & at the same time transparently gilded then the cheeks — the latter former — the Irides are of a brilliant gold — the back to below the lateral line appears of a darkish hue 'tho on their parts, they are tinged with silver, all the fins & the tail are red — Dorsal Fin has nine rays, each branched off at the extremities & the first one is toothed or jagged, on the inner edge — Pectoral Fins have 5 Rays, also branched off like the dorsal — the Anal Fins have nine — the ventral Fins also, all these are rounded off like the Dorsal Fin & the tail has 18, which are branched off or subdivided towards their ends — the belly is silvery white — the Barbel attains to the weight of 15 pounds.

The Barbel

Pencil. Transfer drawing by BEWICK for the engraving for the intended *British Fishes*; first published in Bewick's *Memoir*, 1862, p. 303. Title and notes inscribed in Bewick's hand. *Coll:* Natural History Society of Northumbria.

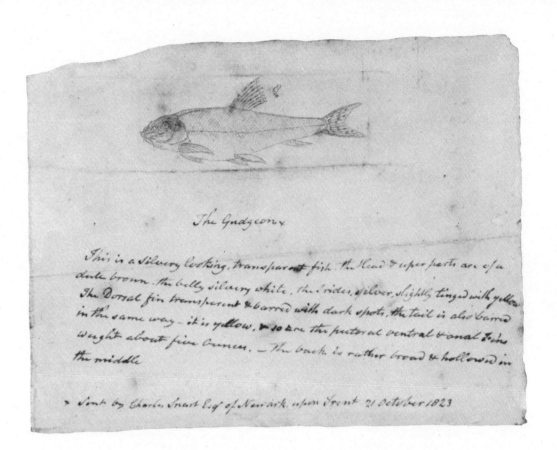

The Gudgeon

This is a Silvery looking, transparent fish, the Head & upper parts are of a dull brown, the belly silvery white, the sides, silver, slightly tinged with yellow. The Dorsal fin transparent & barred with dark spots, the tail is also barred in the same way – it is yellow, & so are the pectoral ventral & anal fins. Weight about five ounces. – The back is rather broad & hollowed in the middle

Sent by Charles Snart Esq of Newark, upon Trent 21 October 1823

The Gudgeon

Pencil. Transfer drawing by BEWICK for the engraving for the intended *British Fishes*; first published in Bewick's *Memoir*, 1862, p. 305. Title and notes inscribed in Bewick's hand. *Coll:* Natural History Society of Northumbria.

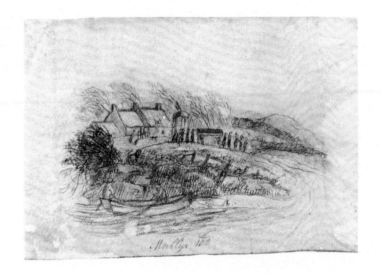

'The Ferry waiting for the Coffin'

Pencil. Study by BEWICK for his tail-piece engraving published posthumously in his *Memoir*, 1862, p.286, and probably intended for the *History of Fishes*. Jane Bewick to Edward Ford, 2 April 1862 (Ford MSS): 'The date on the back of the cut shows it to have been the last vignette, my Father ever cut.' A distant 'signpost' cross is added in the engraving – 'to signify the Christian's hope in life and death' (Robinson p.161). The scene is clearly reminiscent of Cherryburn and the Eltringham ferry ready to make the crossing of the Tyne to Ovingham churchyard. The inscription at the foot of the study, in Bewick's hand, 'Mullys $\frac{6}{180}$', seems too carefully placed to be an incidental memorandum and perhaps refers to a bequest or payment dependent on Bewick's death. *Coll:* Natural History Society of Northumbria.

MISCELLANEOUS
BOOK ILLUSTRATION
AND
JOBBING ENGRAVINGS

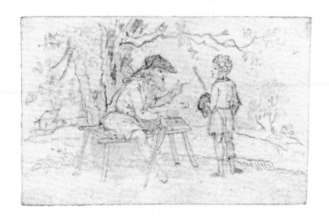 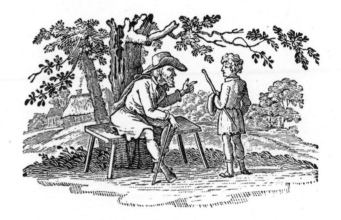

'How the Wyse Man taght hys Son'

Pencil. Transfer drawing by JOHN BEWICK for his engraving in Joseph
Ritson's *Pieces of Ancient Popular Poetry*, 1791, p. 83. *Coll:* Natural History
Society of Northumbria.

'In Arthur's Court Tom Thumbe did Live'

Pencil. Transfer drawing by JOHN BEWICK for his engraving in Joseph
Ritson's *Pieces of Ancient Popular Poetry*, 1791, p.99. *Coll:* Natural History
Society of Northumbria.

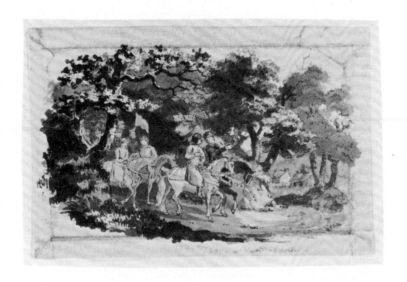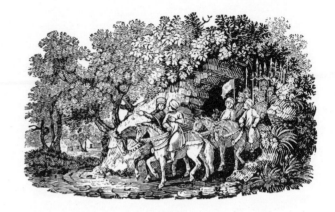

'Griselidis'

Pen and wash. Transfer drawing by ? NESBIT for his engraved head-piece to the tale of 'Griselidis' in Le Grand's *Fabliaux*, translated by Gregory Way, Vol. II, 1800, p. 109. Some of the foliage in the engraving may have been worked by Bewick. *Coll:* Natural History Society of Northumbria.

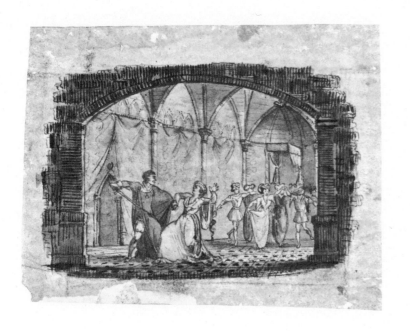
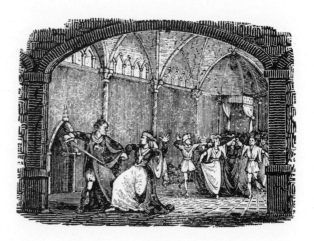

'The Countess of Vergy'

Pen and wash. Transfer drawing by ? NESBIT for his engraved head-
piece to the tale of 'The Countess of Vergy' in Le Grand's *Fabliaux*,
translated by Gregory Way, Vol. II, 1800, p. 131. *Coll:* Natural History
Society of Northumbria.

'The Lay of Sir Lanval'

Pencil. Transfer drawing by BEWICK for his engraved tail-piece to 'The Lay of Sir Lanval' in Le Grand's *Fabliaux*, translated by Gregory Way, Vol. I, 1796, p. 173. *Coll:* Pease Bequest.

'The Knight and the Sword'

Pencil. Transfer drawing by BEWICK for his engraved tail-piece to the
tale of 'The Knight and the Sword' in Le Grand's *Fabliaux,* translated by
Gregory Way, Vol. I, 1796, p. 142. *Coll:* Pease Bequest.

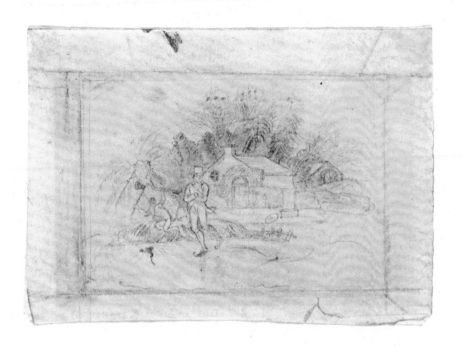

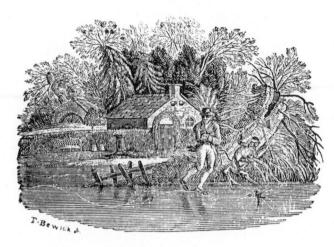

A Monkey and an Unwary Skater

Pencil. Transfer drawing by BEWICK for his vignette engraved for his friend J.F.M.Dovaston of Westfelton, Shropshire. Used as a final tail-piece in Dovaston's *Poems*, 2nd edition, Shrewsbury, 1825. 'With the cut I very honestly say I am highly pleased; but as honestly add that I do not think it executed in your very best manner. This, however, do me the justice to believe, I do not attribute to any want of care or kindness on your part; particularly when I with real sorrow read & regret the illness that in your last letter, you say affects your eyes, about which time this block was cut.' (Dovaston to Bewick, 20 February 1824. Copy letter in Dovaston's MS Commonplace Book, Ohio State University.) *Coll:* Natural History Society of Northumbria.

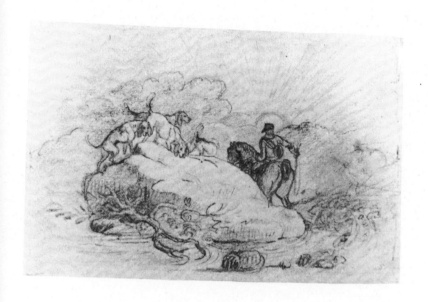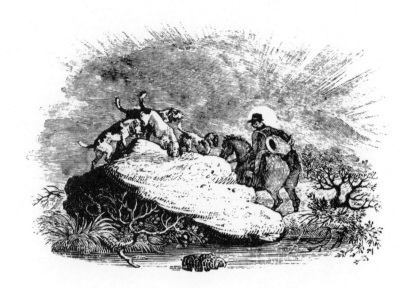

A Huntsman and Hounds

Pencil. Transfer drawing by BEWICK for his title-page vignette engraved for William Somervile's *The Chase*, 1796. All the other illustrations for the book had been designed by John Bewick shortly before he died. *Coll:* Pease Bequest.

A Traveller and his Dog on a Windy Day

Pencil and wash. Transfer drawing by ? THURSTON for the apprentice
tail-piece engraving in *The Poetical Works of Robert Burns* Vol. 1, Alnwick,
1808, p. 209. *Coll:* Pease Bequest.

A Countryman and his Donkey

Pencil. Transfer drawing by BEWICK for the apprentice tail-piece engraving in *The Poetical Works of Robert Burns* Vol. 1, Alnwick, 1808, p. 260. Inscribed in Jane Bewick's hand: 'Designed by Thomas Bewick.' *Coll:* Pease Bequest.

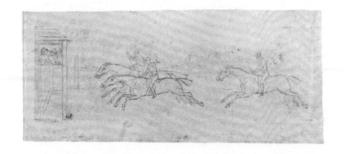

The Finish at a Race Meeting

Pencil. Transfer drawing by BEWICK for an engraved head-piece to a newspaper advertisement or race card. A subject repeated on many occasions. The engraving shown here is reproduced from Hugo's *Bewick's Woodcuts*, No. 1511, 1870, who records that the block came from Soulby's printing office, Penrith. *Coll:* British Museum.

Bookplate for William Armstrong,
Merchant, Newcastle

Pencil. Transfer drawing by BEWICK for his engraving. The block was
altered for use by Jane Bewick on the title-page of Bewick's *Memoir*,
1862. The inscribed rock and foliage was a theme repeated on many
occasions. *Coll:* Pease Bequest (drawing); British Museum (original
state of engraving).

John Bewick's Bookplate

Pencil. Transfer drawing by JOHN BEWICK for his own engraved bookplate.
Later used by his niece Jane Bewick. *Coll:* British Museum (drawing); Julia
Boyd's *Bewick Gleanings*, 1886 (engraving).

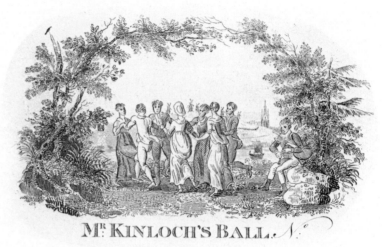

Mr KINLOCH'S BALL. Nº

Ticket for Mr Kinloch's Ball

Pencil. Study by BEWICK for the copperplate etched by ROBERT BEWICK
*c.*1812, for Alexander Kinloch, a Newcastle dancing master. The musician is
playing the Northumbrian small-pipes, an instrument on which Robert Bewick
was a virtuoso. The spire of St Nicholas's Church, Newcastle, is seen in the
distance. *Coll:* Natural History Society of Northumbria (drawing); Julia Boyd's
Bewick Gleanings, 1886 (etching).

Berwick Bank £5

181 N°

Promise to pay or Bearer

on demand FIVE POUNDS Value received

FOR Mowbray, Hollingsworth, Wetherell

Five Pounds Mason, Bailey & Langhorn

Ent.

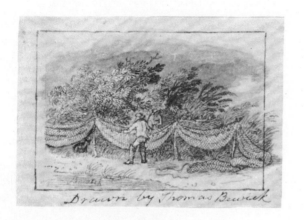

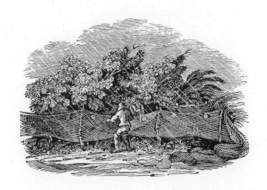

'Fishermen drying Nets'

Pen and wash. Study by BEWICK for the apprentice tail-piece engraving in *Fables of Aesop*, 1818, p. 250, and for the vignette on a Berwick Bank £5 note. Tail-piece engraved during the week ending 18 September 1813 (R. 38 Laing). The banknote vignette is etched and shows Bewick's remarkable skill in achieving the effect of wood engraving particularly with the white-line cross hatching on the net. *Coll:* British Museum (drawing); Iain Bain (banknote).

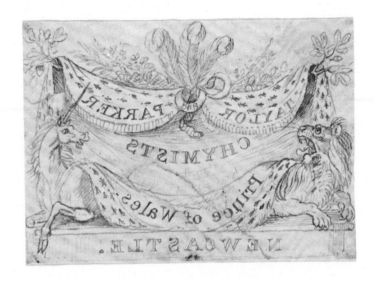

Trade Card for Taylor & Parker, Chemists

Pencil. Transfer drawing by BEWICK for wood engraving. *Coll:* British Museum.

Ticket for Jones & Parker's Circus, 1789

Pen and wash. Study by BEWICK for wood engraving. Inscribed in Jane Bewick's hand: 'Thomas Bewick delt Jones & Parkers Circus, Forth, Newcastle.' *Coll:* British Museum.

A Waggon and Horses

Pencil. Study by BEWICK for his engraving on a silver box. The burnished impression from the box is inscribed in Jane Bewick's hand: 'Impression from M^r Crow's Silver box.' *Coll:* British Museum (drawing); Iain Bain (print).

Coats of Arms

Pencil. Studies by BEWICK for two coats of arms either for bookplates or for engraving on silver. *Coll:* British Museum (left); Iain Bain (right).

A Running Hare

Pencil. Drawing and cut template by BEWICK for engraving on silver. The
cut template served as a guide for a fine-pointed stick which marked the
outlines on the chalked surface of the silver. This method helped to keep the
drawing correct when applied to a curved surface. The motto to be engraved
'Nec temere, nec timide' – 'neither rashly nor timidly' is inscribed in
Bewick's hand along the bottom edge of the paper. *Coll:* Iain Bain.

APPENDIX 1

Apprentices and their Workshop Periods

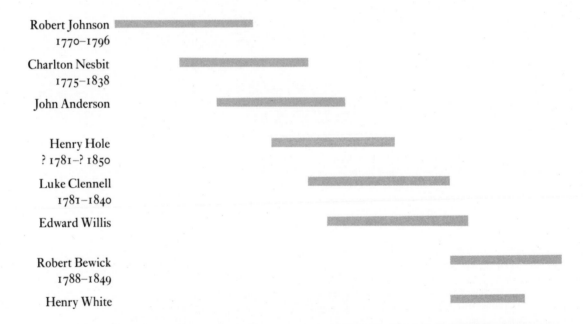

1787 88 89 90 91 92 93 94 95 96 97 98 99 1800 01 02 03 04 05 06 07 08 09 10

Quadrupeds ❭❬ *British Birds* Volume I ❭❬ *British Birds* Volume 2 ❭

Robert Johnson
1770–1796

Charlton Nesbit
1775–1838

John Anderson

Henry Hole
? 1781–? 1850

Luke Clennell
1781–1840

Edward Willis

Robert Bewick
1788–1849

Henry White

Johnson 23 August 1787 to 23 August 1794; Nesbit 5 June 1790 to ? June 1797; Anderson 10 September 1792 to ? September 1799; Hole 24 March 1795 to 3 October 1801; Clennell 8 April 1797 to 7 April 1804; Edward Willis ? July 1798 to 17 August 1805; R. Bewick 26 May 1804 to 26 May 1810; White 29 November 1804 to 9 January 1808. *Other apprentices include* John Bewick (1760–1795) 1777 to 1782; Isaac Nicholson (1789–1848) 18 August 1804 to 6 July 1811; William Harvey (1796–1866) 27 November 1809 to 9 September 1817; William Temple ? August 1812 to 14 August 1819.

APPENDIX 2

The Dispersal of Bewick's Workshop Drawings

The earliest evidence we have of an outside interest in Bewick's preliminary drawings is to be found in a letter of 4 April 1805, which he had from a Mrs Sophia Mackenzie in London: 'The little drawing Capn Mitchell presented me from Mr Bewick, will be placed in a book with the others I had at Newcastle, which I have the greatest value for, & should be very happy if either business or pleasure brought Mr Bewick to London to shew them to him in the highest preservation . . .'.[1] Bewick replied that he was glad that the drawings had pleased her, and that had he foreseen that the sketches had any value for her, he would not have burnt so many of them.[2] It may indeed be this burning that accounts for the relatively small number of drawings for the *Quadrupeds* that have survived.

In 1823 and 1825 Bewick was visited by John Dovaston from Shropshire, who became a good friend and the recipient of a series of letters that provide more personal detail relating to Bewick's last years than any other part of the surviving correspondence. On one of these two visits Dovaston was given a small group of watercolour drawings, together with a larger number of light impressions of figures from the *Birds*, exquisitely coloured.[3]

After Bewick's death, the family were reminded by a friend that their father had agreed he might borrow the drawings to show to his own acquaintances.[4] Apart from the display of a very small group at the Newcastle Exhibition of 1822, this is the only other evidence that might suggest that they were more widely known in Bewick's lifetime.

During the years that followed, Bewick's daughters were visited from time to time by a number of their father's admirers, anxious to acquire items of special interest for their collections. The ledgers that were kept to record the continuing sale of the later and posthumous editions of the *Birds*,[5] also note the sale or presentation of a number of drawings to some of these visitors. Apart from two subjects 'on the wood' which were sold to William Howitt in 1841,[6] all the transactions relating to drawings appear in the years following Robert Bewick's death in 1849, when the closing of the engraving shop must have reduced his sisters' income to the point where the sale of some of their father's relics became, if not necessary, at least helpful. In relation to the whole collection the number of drawings they parted with was small, and while some have yet to be found others have been traced to present-day collections.

In May 1853, five watercolours, and fifteen pencil sketches, all relating to tail-piece engravings, were sent on

[1] Laing Gallery MSS. [2] Draft MS, Laing Gallery, written on the original from Mrs Mackenzie. [3] Now in the Editor's collection, having been discovered in one of Dovaston's scrap albums sold at the dispersal of his descendants' property at West Felton, Shropshire, in 1966. [4] Henry Hewitson to Jane Bewick, 1829 (Editor's Collection). [5] Laing R72. [6] The blocks were then engraved by Samuel Williams, quite in his own manner, for use in the second edition of Howitt's *The Rural Life of England*, 1842.

approval to Edward Ford of Old Park, Edmonton, near London, who had already been presented with three sketches on an earlier occasion. All but three were bought, and in November of the same year, Ford acquired a further five drawings. He continued to keep in touch with Jane Bewick. Much of their correspondence survives[1] and it records the negotiations for further purchases – mostly of books and impressions of the engravings. No more drawings were bought until November 1869 when he acquired five pencil studies of birds and animals and a group of thumbnail portraits. Most of this collection survives intact with his great-grandson, Dr Edward Ford.

In 1853, a Mr Crompton bought two tail-piece drawings, and in 1857 'a few pencil sketches' were sold to Kerslake, a Bristol bookseller, two of them of owls and the others of tail-piece subjects. Seven years later, in 1864, perhaps in the hope of defraying some of the expenses incurred in her publishing of the *Memoir*, and perhaps to test the market, Jane Bewick sent a small group of drawings to the auction rooms of Puttick and Simpson in London. She must have been disappointed: two watercolours and two pencil drawings of birds, were sold for £1, and three tail-piece vignettes (two in colour and one in pencil) fetched £1.10s. – sums less than she was sometimes able to get from private transactions.

1868 saw the beginning of the sale of the largest number of drawings to go directly to a private collector. Edward Basil Jupp, who was Clerk to the Carpenters Company and an antiquary still remembered for his extraordinary collection of early art exhibition catalogues, began his purchases with eight assorted drawings – designs for bookplates, a large tiger, a drawing of Prudhoe Castle by John Bewick, and some tail-piece designs. In the following year he bought thirty-three pencil drawings, mostly of tail-piece subjects, but with a sprinkling of preliminaries for jobbing engraving. In 1870 he acquired nine further pencil drawings and a group of eight small thumbnail portraits of Scotchmen. Shortly before his death in 1877, Jupp visited the two old ladies in Newcastle and among other relics bought '24 designs of birds' for £20, all of them probably in pencil. At the sale of his Bewick collection in the following year a number of these were bought by Ruskin.

The last of the transactions recorded in the ledger tells us that a Lady James of Bettshanger Park, Kent, bought six pencil drawings of animals in 1877, paying the £5 independent valuation she arranged in London. It is very probable that people who saw the Bewick sisters regularly during their later years were given drawings for which there is now no record, but three we do know of were J.W. Barnes, Joseph Crawhall and John Hancock. All were personal friends and Barnes and Crawhall had been appointed executors of their wills. The Barnes collection of 134 pencil drawings, some of which he had obtained from other sources, is now in an album in the Pease Collection at the Central Library, Newcastle upon Tyne. It is important for the fifty-four figure drawings for the *Quadrupeds* which are not well represented elsewhere. A few subjects from Crawhall's collection are now also in the Pease Collection; John Hancock gave his small group of drawings to the Natural History Society in Newcastle.

During the 1870s, Jane and Isabella had been considering the best place to which they should bequeath the main body of the drawings. A long letter from Sidney Colvin, Slade Professor of Fine Art at Cambridge, written in 1873, urged Jane Bewick to consider the Fitzwilliam Museum, and suggested that she should without delay have a proper

[1] In the collections of Dr Edward Ford, V & A and the Editor.

inventory and valuation prepared by the Keeper of Prints and Drawings at the British Museum. He pressed her to consider the fact that

Nothing serves so well the reputation of a great artist, such as your father, as that a large quantity of his work should be kept *together*, where it can form a Museum to be seen and studied. At Cambridge, you might count on the drawings and cuts of Bewick being religiously cared for, and made the objects of study for all time to come. Nothing, on the other hand, so much injures an artist's reputation as that his works should go to the hammer and take the chances of the market. True, they may in the first instance fetch a higher figure by that means (but *that* is not your object); but they get hidden from public view among private collections; they change from hand to hand, and become subject to loss and deterioration; there ceases to be any possibility of studying the artist's genius *as a whole*, and so doing it full justice.' Colvin continued by emphasising that his arguments applied as strongly to the original wood blocks, which the sisters had retained in their entirety – 'the finest specimens of the wood-engraver's art that the world has seen.[1]

His hopes for Cambridge and the Fitzwilliam came to nothing. On the back of his letter Jane Bewick wrote: 'British Museum or *National* Gallery – rather inclining to the *former* 15th March 1875.' From the evidence of a letter of 24 January 1882 from her cousin Robert Ward, a printer in Newcastle, to G.W. Reid (then Keeper of Prints and Drawings at the British Museum), Jane must have written to the Museum in 1875:

I am instructed by Miss [Isabella] Bewick to say that she feels disposed to send to the British Museum at once a collection of her Father's Drawings and Prints, but would not like to send more than would be fully appreciated and exhibited to the public. The Drawings would require to be shown in cases or frames to prevent their being handled or otherwise injured. Will you kindly say what space you can permanently devote to their exhibition? She could send you a number of Water-colour Drawings properly mounted on cardboard 14in by 18in and two large books of impressions from the blocks. The latter of course could not be openly exhibited, but would have to be shown subject to such restrictions as you might deem necessary for their preservation. I write this having before me your letter to the Misses Bewick of July 24th, 1875 and also the copy of a letter from you to J.W. Barnes Esq., of Durham, dated June 30th, 1879. I do so in the presence of Miss Bewick who desires me to send you her best respects.[2]

This letter was written after Jane Bewick's death. In the March following Ward's letter, her sister Isabella (who herself had little time to live) sent the British Museum 395 drawings, 198 of them in watercolours. An exhibition was set up in the King's Library but it was clearly impossible to retain this permanently. Other correspondence relating to the gift has yet to come to light, but it seems very unlikely that the Museum could have offered more than careful housing. When Isabella died in 1883, her executors, Barnes and Crawhall, presented the remainder of the drawings, over seven hundred of them, to the Hancock Museum in Newcastle. This opened in the following year as a home for the collections of the Natural History Society of Northumberland, Durham and Newcastle upon Tyne.[3]

[1] Editor's Collection.　[2] Draft MS, Editor's Collection.　[3] Renamed in recent years, the Natural History Society of Northumbria.

APPENDIX 3

The Present-day Collections

Nearly 1,500 of Bewick's workshop drawings are at present to be found in public and private hands. Over 1,300 of them are in the three public collections to which they were presented during the final twenty years of the last century, namely the British Museum, the Natural History Society of Northumbria, and the Pease Collection at the Central Library, Newcastle upon Tyne. The greater part of these collections contain drawings that were actually used for the process of transferring the design to wood blocks. Six other public bodies in England have small groups of drawings: the Hornby Art Library, Liverpool, has forty-one related to the *Fables of Aesop*, all in pencil or pencil and wash, and all mounted in a copy of the book; the Victoria & Albert Museum has three coloured drawings; the Courtauld Institute, London, has one in colour; the Ruskin Galleries, Bembridge, Isle of Wight, six pencil drawings of birds; the Department of Fine Art, University of Newcastle upon Tyne, ten pencil vignettes and sketches; and the Laing Art Gallery and Museum, Newcastle upon Tyne, has five larger subjects, four of which are in colour. The Laing Gallery also has fifty-three large sepia wash drawings of birds, quadrupeds and tail-pieces which are so uncharacteristic that they can only be assumed to be the work of a later hand inspired by the finished engravings. They are at least twice the size of the engravings and none is reversed. In the Carlisle Art Gallery there is a fine large study of a dead bird hanging in a tree, once attributed to Bewick, but about which there is now some doubt.

At the British Museum the 395 drawings are catalogued under the names of John Bewick (thirty), Robert Elliot Bewick (138 – seventy-six of these being fishes) and Thomas Bewick (227). 157 of the master's drawings are related to the *Birds*, and forty-four of these are the highly finished watercolour tail-pieces most of which are now associated with Robert Johnson. There are seventy-three of Bewick's coloured figures of birds. Of the fifty-four miscellaneous subjects six are in colour. An as yet unidentified edition of *Aesop's Fables* is represented by seven coloured drawings catalogued under Robert Bewick's name, but which may have been the work of Robert Johnson.

The Natural History Society of Northumbria now has by far the largest assembly of drawings. 725 of them are grouped on 133 mounts. There is a further group of about forty unmounted sketches by Robert Bewick, most of them studies of animals. 230 drawings in the collection are coloured, and of these 153 are of birds, ninety-two being foreign species, very few of which were engraved. The other 185 drawings of birds are in pencil. Sixteen drawings for the *Fables*, mostly in pencil or pen and wash, supplement those in the Hornby Art Library. Miscellaneous tail-pieces and jobbing engraving designs number 304, of which thirty-five are coloured. A few of this group are by hands other than those of Bewick or his son.

When J.W. Pease bequeathed his great Bewick collection to the City of Newcastle in 1901, it included an album of drawings and letters collected by J.W. Barnes. This contains 134 pencil and two coloured drawings. Fifty-four of these are figures and twenty-four are tail-pieces for the *Quadrupeds*. The fifteen other separate drawings in the Pease Collection include four large studies of birds.

In America, the Houghton Library, Department of Printing and Graphic Arts, has a collection of twenty-six drawings, nine of which appear to be by apprentice or other hands. Of the remainder nine are tail-pieces, and two are figures, both for the *Fables*. The Newberry Library in Chicago has an album of twenty-three pencil drawings, formerly in the collection of L.G. Duke. It includes five birds, two quadrupeds and sixteen tail-pieces.

Of private holdings, four in England and two in America have been traced. Dr Edward Ford has twenty drawings inherited from his great-grandfather who bought most of them from Jane Bewick; seven of these are coloured. Sir Geoffrey Keynes has the fine study of feathers reproduced in Vol.2, p.207. Mr Peter Summers has a watercolour of Cherryburn by John Bewick, and the Editor has eleven drawings, eight of them coloured, four of which are by apprentices. In America Mr S. Dillon Ripley has three pencil drawings – a bird and two tail-pieces, and Mr and Mrs Paul Mellon have a coloured drawing of a quadruped.

There are still a number of subjects to be found which are known from the records of later exhibitions and sales, as well as from the Bewick family papers. Their small size makes it inevitable that some should be bound into copies of the books, and some may yet be in the six out of ten grangerised copies of the *Memoir* prepared by Jane Bewick in the 1860s which have still to be traced. Naturally it would be useful to hear of the whereabouts of any subjects that may have been missed.

From time to time drawings appear which are attributed to Bewick, but which are by later hands inspired by the finished engravings – such as those now in the Laing Gallery, but more usually of the same size, or near to the size of the originals. That they are not reversed yet include all the detail of the engraving should put us on our guard.

Because they were for the most part prepared for the workshop, many of the drawings show signs of use, the most obvious being the crease marks of their application to the blocks. The condition of the colour is in general very good, except for some subjects in the Natural History Society of Northumbria's collection. When first acquired they were for a long time on public display and they have suffered the inevitable effects of exposure to daylight: some of this damage is evident in the reproductions in this book, which show the change of paper colour in the areas exposed by the mount aperture.

A number of drawings carry the signatures or initials of Bewick or his son Robert, which were applied by Jane Bewick in her later years. In some cases, notably the *Fables* subjects in the British Museum, her memory may have failed her. The large pencilled figures in the corners of the drawings at the Natural History Society of Northumbria are in the hand of John Hancock and were presumably added during his cataloguing of the collection.

FURTHER READING

The most scholarly record of Bewick's principal works is Sidney Roscoe's *Thomas Bewick, a Bibliography Raisonné*, Oxford, 1953, reprinted 1973, which the serious student must now supplement by referring to the workshop records (see note on the Laing Gallery p.11); these were unknown to Roscoe at the time. Thomas Hugo's *The Bewick Collector*, 1866, with its supplement, 1868, is by contrast a slipshod work; though valuable for the vast amount of material surveyed it contains much of doubtful attribution. The fine Bewick collection of J.W. Pease now in the Central Library, Newcastle upon Tyne, is usefully recorded in the *Catalogue of the Bewick Collection (Please Bequest)* by Basil Anderton and W.H. Gibson, 1904. A Check-list of the Manuscripts of Thomas bewick, compiled by Iain Bain, 1970, although now known to be incomplete, is the only survey of Bewick's surviving correspondence and other papers. Iain Bain's *Thomas Bewick: an Illustrated Record of his Life and Work*, Laing Gallery, 1979, presents the most extensive visual record of Bewick's workshop activity.

The most useful nineteenth-century works based on personal acquaintance are: G.C. Atkinson, 'Sketch of the Life and Works of the late Thomas Bewick' in the *Transactions of the Natural History Society of Northumberland ...*, i, 1831; and J.F.M. Dovaston, 'Some Account of the Life, Genius and Personal Habits of the late Thomas Bewick' in Loudon's *Magazine of Natural History*, Nos 9–12, 1829–30. Other nineteenth-century works include: Robert Robinson, *Thomas Bewick, His Life and Times*, 1887 and D.C. Thomson, *The Life and Works of Thomas Bewick*, 1882. In the present century Montague Weekley's *Thomas Bewick*, 1935, gives us the only modern biography, written with much insight but without reference to the manuscript sources which have since become available. Other shorter appreciations are given in Graham Reynolds' *Thomas Bewick: a Résumé of his Life and Work*, 1949, and John Rayner's *A Selection of Engravings on Wood by Thomas Bewick*, 1947. The introduction to Reynolds Stone's *Wood Engravings of Thomas Bewick*, 1953, is valuable for the insights of a practising engraver working in the Bewick tradition. The most important supplement to Bewick's own *Memoir* (edited by Iain Bain, Oxford, 1975) and full of detail relating to the later years of his life, is to be found in *Bewick to Dovaston: Letters, 1824–28*, edited by Gordon Williams, 1968. *Thomas Bewick Vignettes*, edited with an introduction by Iain Bain, 1978, provides some assistance towards a more precise approach to attributions, and makes use of some of Jane Bewick's notes on the narrative content of her father's tail-pieces.

INDEX

Fitzwilliam Museum as repository for TB's drawings, 223; negotiations for bequests of TB's drawings, 223; requests TB to withdraw offensive tail-pieces, II, 179

Bewick, John, 1760–95, TB's younger brother, wood-engraver, moves to London, 24; visit to Royal Academy exhibition (1787), 26; visit to Bartholomew Fair (1787), 26; writes of TB's prospectus for *Quadrupeds* (1788), 27; buys boxwood for TB, 58n; term of apprenticeship, 61; drawings and engravings by or attributed to, 200, 201; bookplate, 212; drawing of Prudhoe Castle, 222; drawings at the British Museum, 224; watercolour of Cherryburn, 225

Bewick, Robert Elliot, 1788–1849, TB's son and successor, TB's thumb-nail sketch of, 19; receives James Ward's opinion of TB's tail-pieces, 47; drawings for *British Fishes*, 52, 190, 192–3, 194–5; designs and engravings for jobbing work, 55; II, 221, 222, 223, 226–7, 228, 229; 61; manner of engraving illustrated, 62–3; 69n; work illustrated, 73; ill-health, 84; draughtsmanship, 84; interest in perspective drawing, 84; want of confidence and TB's domination, 84; copper-engraving commission from G. T. Fox *qv*, 84; TB's pride in his drawings for *British Fishes*, 85; William Bell Scott's account of him 85–6; other drawings and engravings by or attributed to him, 172, 188, 213; II, 102, 117, 121, 203, 204, 210, 211, 212, 213, 216; drawings in the British Museum, 224, and Natural History Society of Northumbria, 224

Bewick, Thomas, 1753–1828

Memoir qv, 13; early acquaintance with the habits of animals, 14; influence of country boyhood, 14; interest in fables, 14; first woodblocks, 15; beginning of his delight in landscape, 18; walking tour in Scotland (1776), 18; works in London (1776–7), 18; partnership with Ralph Beilby, 18

real interests delayed by need 'to work for the kitchen', 23; corresponds with John Bewick re rare animals in Tower Menagerie, 24, 26–7; work for the fat-stock breeders, 30; only essay in lithography, Edinburgh (1823), 31; on the unreliable illustrations in Pennant's works *qv*, 33n; on his sources for the *British Birds*, 33

endless correspondence with naturalists, 34, 37; visits Tunstall's natural history collections at Wycliffe, North Yorkshire *qv*, 34; opinion of Selby and Mitford's first essays in etching, 42; designs for *Fables of Aesop* (1818), 49; severe illness (1812), 49; engravings for *British Fishes*, 52; views on apprentices, 60

denial of allegations of apprentice contribution to *Quadrupeds*, 64; use of apprentices in *British Birds*, 64; account of Robert Johnson *qv*, 64–5; domination of his son Robert, 84–5; pride in Robert's drawings for the *British Fishes*, 85; William Bell Scott's (*qv*) account of TB and his son Robert, 85–6; few but valued opportunities for seeing work of fellow artists, 86; on his sources of inspiration, 86–7; proposals for the conduct of an artist's life, 87; drawings in British Museum and Natural History Society of Northumbria, 224

as draughtsman and colourist:

early developed talent, 13; early use of colour, 13; thumb-nail portraits, 18, 19, 222; dissatisfaction with his portrayal of motion in animals, 31–2; dissatisfaction with poorly set-up specimens as models, 34; drawings as preliminaries, modified in engravings, 43; drawings as vignettes, 45–6; use of colour, 42–3, 47, 65; drawings for jobbing engraving, 55, 211, 213, 215, 216, 217, 218, 219; II, 225, 228; process of transfer of drawing to wood block, 56, illustrated, 59; dating of drawings, 60; Robert Johnson's colouring of TB's work, 65; comparison of his drawings with those of Johnson, 70, 72–3; first public interest in TB's drawings, 221; his destruction of early examples of his drawings, 221; awareness of birds' changed contours in winter, II, 48

as engraver:

on copper: jobbing work illustrated, 21, 213, 215, II, 225, 228; on silver and gold: jobbing work illustrated, 22, 60, 217; on wood: interpretation of colour, 43; modification of original drawings, 43; time taken to engrave block, 43; light impressions for colouring, 47; work for other publishers and collaboration with other artists, 54–5; process of transferring drawing to woodblock, 56; engraving methods, 56–60; preparation of boxwood, 57–9; reversal of drawings, 58, 60; dating of engravings, 60; various styles of workshop hands illustrated, 62–3

his tail-pieces:

titles of, 11; delight in their invention, 45–6; universal praise of, 46–7; their portrayal of rural life, 47; their narrative content, 47; for *Fables of Aesop*, 52; provide ideas for Mozley, Gainsborough bookseller, 55; apprentice engraving of, 64; Chatto and Jackson's attribution list, 69–70; topographical references in, *see*: Alnmouth; Bywell Castle; Bywell Hall; Cherryburn; Haydon Bridge; Hexham; Marsden Bay and Rock Arches; Millfield Plain; Ovingham; Rimside Moor; St Nicholas' Church, Newcastle; Warkworth Castle; Windmill Hills, Gateshead

Blackwood's Magazine, reviews TB's work, 47

Boothby, Sir Brook, 1743–1824, author of *Fables and Satires* (1808), celebrated in tail-piece engraving, II, 213

Boreman, Thomas, *fl.* 1730–40, author of *A Description of Three Hundred Animals*, 23

boxwood, as prepared for engraving, 57–9

Boyd, Julia, d.1892, Bewick collector and author of *Bewick Gleanings*, (1886), 16, 49n

Breadalbane, John Campbell, 4th Earl of, 1762–1834, at whose seat Robert Johnson (*qv*) died, 65, 67

British Birds, A History of (1797–1804), 23; preparations for, 33; TB's sources, 33; early prospectuses, 35; plans for, 36; time lost in drawing foreign birds, 36; difficulty with stuffed specimens, 36; assistance from sporting friends, 36; publishing success, 37; Charles Kingsley's opinion of the book, 37; title-pages and openings illustrated, 38–9, 40–1; most successful subjects, 43; apprentice